Extraordinary
HAND LETTERING
Creative Lettering Ideas for Celebrations, Events, Décor & More

McKenzie Co. Public Library
112 2nd Ave. NE
Watford City, ND 58854
701-444-3785
librarian@co.mckenzie.nd.us

Doris Wai

WITHDRAWN

Skyhorse Publishing

Copyright © 2017 by Doris Wai

All rights reserved. No part of this book may be reproduced in any manner without the express written consent of the publisher, except in the case of brief excerpts in critical reviews or articles. All inquiries should be addressed to Skyhorse Publishing, 307 West 36th Street, 11th Floor, New York, NY 10018.

Skyhorse Publishing books may be purchased in bulk at special discounts for sales promotion, corporate gifts, fund-raising, or educational purposes. Special editions can also be created to specifications. For details, contact the Special Sales Department, Skyhorse Publishing, 307 West 36th Street, 11th Floor, New York, NY 10018 or info@skyhorsepublishing.com.

Skyhorse® and Skyhorse Publishing® are registered trademarks of Skyhorse Publishing, Inc.®, a Delaware corporation.

Visit our website at www.skyhorsepublishing.com.

10 9 8 7 6 5 4 3 2 1

Library of Congress Cataloging-in-Publication Data is available on file.

Cover design by Doris Wai and Jane Sheppard
Front and back cover photo credit by Janet Kwan Photography
Cover digital lettering by Doris Wai

Individual photo credits by page:
 Janet Kwan Photography: iii, vi, 2, 4, 6, 8–10, 12, 14, 15 (tape), 16–20, 23, 24 ("pie" window), 25, 30–35, 38–41,
 46, 128, 142
 Doris Wai: 5, 7, 15, 22, 24 (mirror), 26, 28, 36–37, 42–45, 144
 Amsis Photography: 129

Hardcover print ISBN: 978-1-5107-3122-6
Flexibound print ISBN: 978-1-5107-2191-3
Ebook ISBN: 978-1-5107-2192-0

Printed in China

TABLE OF CONTENTS

INTRODUCTION

Extraordinary Hand Lettering is really a cultivation of a lifetime of all my passions combined. Illustration and lettering, DIY projects, party planning, interior design, and giving thoughtful and personal gifts, not necessarily in that order.

Along with my drive to constantly find new tools, writing equipment, and surfaces to letter on, I have created this book to share my ideas and inspirations when it comes to lettering and using it in your everyday lifestyle. Interesting fact: besides the flowers, almost every item, including the lemons, on the cover of this book can be lettered on—flip to the cover to take a peek!

Within these pages, I will introduce to you the basics of hand lettering and design, the multitude of tools I use for different surfaces, simple word composition and knowing what words to emphasize—and in the process, I hope to open your mind up to countless DIY ideas. This book will teach you to use lettering in a meaningful way to create signage for the special moments in our lives, such as weddings and birthdays. You will learn to take beautiful objects, such as mirrors and vintage windows, and transform them into art with your favorite quotes or the words you live by. *Extraordinary Hand Lettering* will take lettering beyond paper, guiding you toward transforming things—old can become new, new can become special. You will learn the purpose for lettering, not only for its beauty, but for function as well.

This book is really for anyone with the slightest passion for lettering, DIY, and styling celebrations. From the lettering novice to the creative calligrapher and hand lettering artist. It is for the party planning mom as much as it is for the professional event planner. It is for the friend who loves to make personal gifts and also for the interior designer creating an accent wall. Essentially, all the above really just describes me, with one common thread—the love of lettering.

My approach to this book is quite simple. Although it is a guide, think of it as a conversation between friends: I am chatting with you about what I am working on; my thoughts and ideas are coming to life as I share them with you. A majority of these projects were lettered on the actual day of the shoot; there are no smoke and mirrors or double takes, and you are seeing me letter raw and in action. Nothing fancy needed. I didn't even do my nails in some of these shoots, so I hope the ideas are so interesting that my less-than-stellar cuticles will go unnoticed!

I hope that by the end of this book you will have discovered a movement to turn lettering into a lifestyle. Transform what you have learned into a way of life and an art form with a purpose. If you aim for lettered perfection, you are missing the mark; but if you aim for meaningful messages straight from the heart that are made with your hands, your project will always be successful.

Enjoy, and happy lettering!

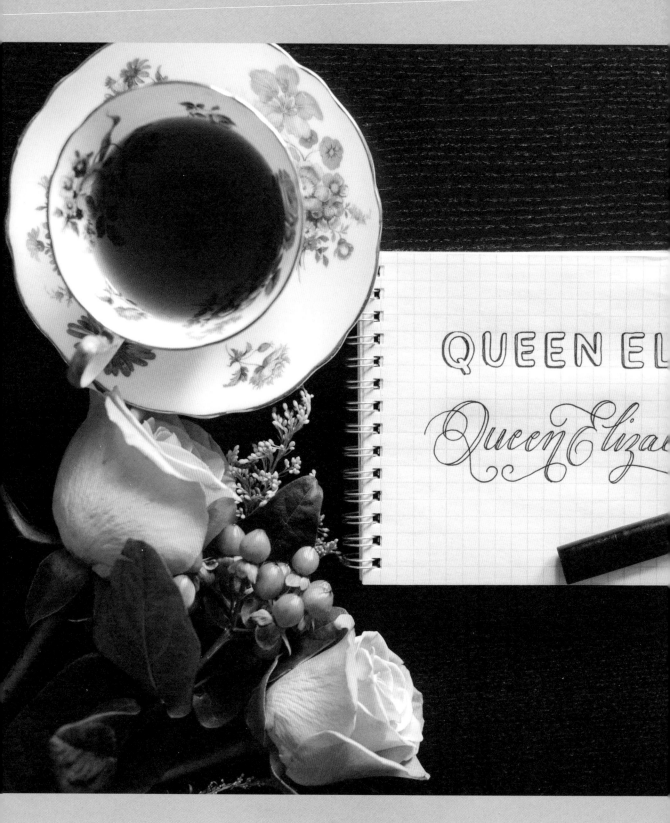

CHAPTER 1

LETTERING BASICS

My obsession with lettering started in grade school—fifth grade, to be exact—when I discovered bubble letters in a book I ordered through the Scholastic book program. That bubble font just made everything look so cheerful and cute, and in that moment, I realized that letters and type could portray a mood and style and tell a story, as if they were illustrations themselves. I vividly remember through my high school years writing yearbook comments in a typewriter font, specifically to stand out from all the other comments. It didn't matter that it took longer; I simply enjoyed the process of lettering and appreciated the joy it gave to the owner of the yearbook. Whether in letters or gifts, I've always found myself spending a lot of time thinking about how the lettering was presented, and it was no surprise that I finally ended up at the Ontario College of Art & Design studying illustration. In the end, I discovered that what I truly enjoyed most was exploring the infinite array of type and drawing letters. But I always knew this was the case, since fifth grade!

In this chapter, I explain the simple terminology of lettering basics and how to differentiate between calligraphy, typography, and lettering.

Technical Terms & Definitions, Simply Put . . .

Calligraphy is defined as decorative hand writing. It usually involves some form of pen, nib, brush, or ink. Calligraphy is the art of handwriting—it takes lots and lots of practice and is quite unforgiving. Once the pen has been laid to the paper, there's no turning back. Mistakes mean starting over, even if you were crossing the last "t" or dotting the last "i" of a full-page masterpiece that took five hours to complete. For this reason, calligraphy can be daunting, but the flourishes and strokes are an art of their own, and the ability to execute calligraphy is an asset in all aspects of life—penning love letters, signing important documents, and, of course, creating extraordinary hand lettering. If you already have a fascination or love affair with calligraphy, you have an advantage when it comes to creating the similar projects here. This book may open your mind to the materials you can possibly apply your calligraphy to and instruct you on what tools to use.

Typography is the art of arranging type for printing and press. There is a technique and process for selecting typefaces, which involves the style of letters or font, point sizes (the letter size), and tracking (the spacing between letters and words). Typography focuses on the style and specific arrangement of letters and numbers to create visual magic for the print and press. This art of laying out and mapping words comes with the vast options of mixing and matching various fonts and type to produce visual interest.

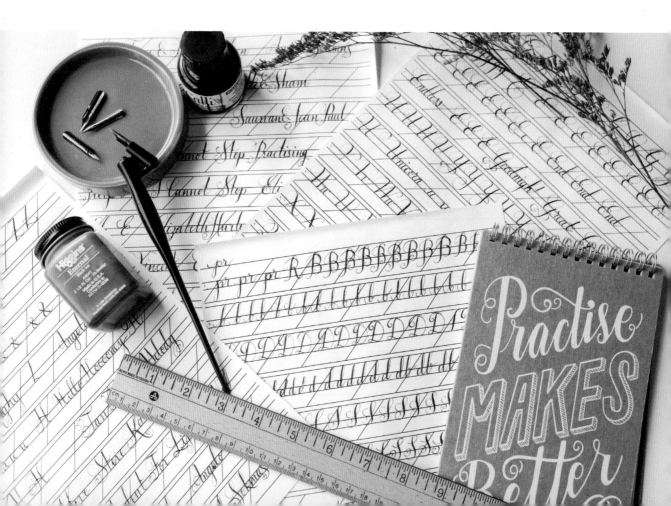

Hand Lettering: If calligraphy is the art of writing and typography is the art of arranging type, spacing, and composition, then hand lettering is the art of drawing letters with calligraphy skills, using typography as a guide. All the projects in this book are achieved with hand lettering. Although it may look like calligraphy, each character is drawn out thoughtfully to resemble it. Design and composition are very important in hand lettering as well, as they are in typography. The combination of these different skills produces hand lettering.

Hand lettering is about being creative with wording and your message. It is about creating visual interest with the letters by changing or trying different fonts in one composition. The magic happens when you choose the right style of lettering to fit your quote/message/sign and emphasize the right words in the process.

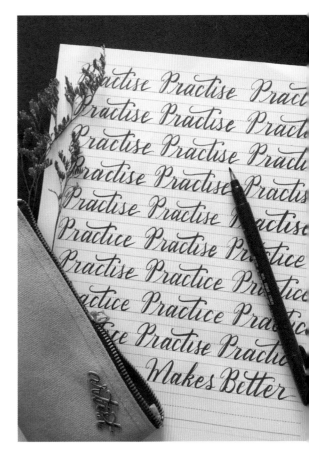

How to Begin Creating & Drawing Type: Basic Lettering

My golden rule for lettering is uniformity and balance. Every letter should be the same size, height, and width in capitals, with the exceptions of the letters "I," which is narrower, and "M" and "W," which are slightly wider. All letters should be spaced evenly as well. To be honest, I eyeball a lot of stuff, including spacing between letters and sometimes even the size of furniture (to my husband's dismay). That said, it's really easy to use a finger, a pencil, or a chopstick to space out your letters when you're lettering for a sign. If you are able to space them evenly and draw capitals at the same height, you have an advantage already! All the projects in this book require mapping on your surface with masking tape or painter's tape.

Non-Script

There are hundreds and thousands of different types of fonts and typefaces, and the differences between each one can be minute. For example, change your sans-serif typeface to a serif typeface with the addition of a couple of tiny strokes:

- Three little strokes can take a regular "A" and transform it into a typewriter-style font (like Courier New)

- Thickening one side creates boldness

- Add a line, and it takes on a modern, Art Deco look

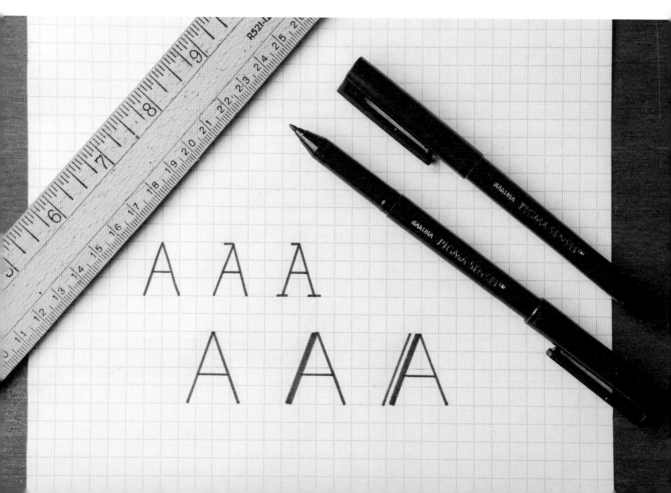

Small and simple strokes change the style completely. Remember to apply the same strokes throughout each letter of the word to create uniformity and balance.

When it comes to what styles suit which project, your eyes will tell you! With so many options to choose from, I will give you just a few of my favorites:

Basic fonts:
Andale Mono (Steve Matteson)
Helvetica (Max Miedinger, Eduard Hoffmann)
Courier New (Howard Kettler)

Masculine, bold, and serious fonts:
Texas Tango Bold (Billy Argel)
Grafton Titling (Neil Patel)
Langdon (XLN Telecom)

Modern and contemporary fonts with clean lines:
Letter Gothic (Roger Roberson)
Vertigo (Cassidy & Greene)
Vevey (Vanessa Lam)

Structured script:
Wisdom (James T. Edmonson)
Cylburn (Dai Foldes)
Fancier (Jess Latham)

Every day, I mentally catalog fonts. Whenever I look at signage, I make mental notes on whether a font looks romantic, cute, modern, bold, etc. Eventually, whenever I have to create something in that category, I already have something to refer to. Sometimes a single letter can be so beautiful that I have to take a photograph of it. With the accessibility of a smartphone camera, I often snap pictures of signs that capture my attention to use as reference at a later date.

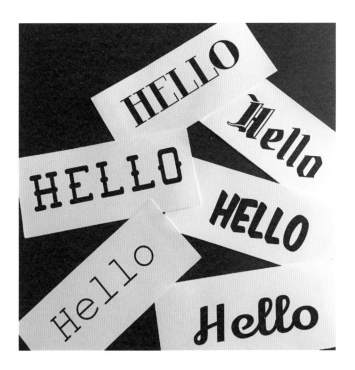

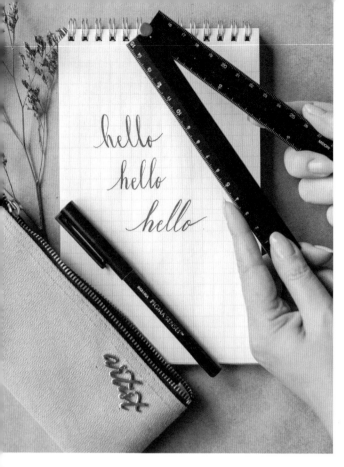

CURSIVE & SCRIPT

Hand lettering script for signage starts with your natural hand writing. If you already practice calligraphy, that helps immensely; if you don't, in the chapters ahead I will show you the rules behind creating your own lettering. In the previous section, you have examples of structured script, which means each letter is the same width and height, with the same spacing in between. The uniformity in the letters creates a clean, feminine look; however, although beautiful, they do not flow and portray character the way cursive script can. In cursive script, balance is still really important—each letter must lean the same way. If it's upright script, all letters must stay upright.

For example, "hello" (left).

There are so many ways to create variation in script, and with enough practice you will develop a signature style. But take a look at one word and all the possible script variations.

For example, "beauty":

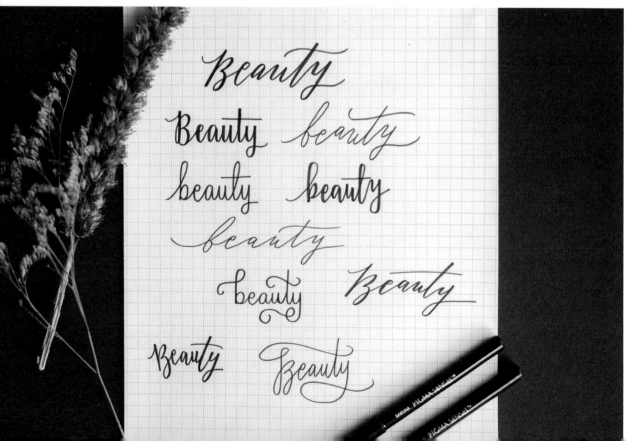

I have to mention: there are some letters that allow you to have way more fun when lettering script. These are my favorites: Lowercase b, d, f, g, h, k, t, y

I mention this because they have strokes and tails that allow for decorative finishes or beginnings. I always get excited to cross the t's and letter the loops.

For example, "happy birthday" and "kitty":

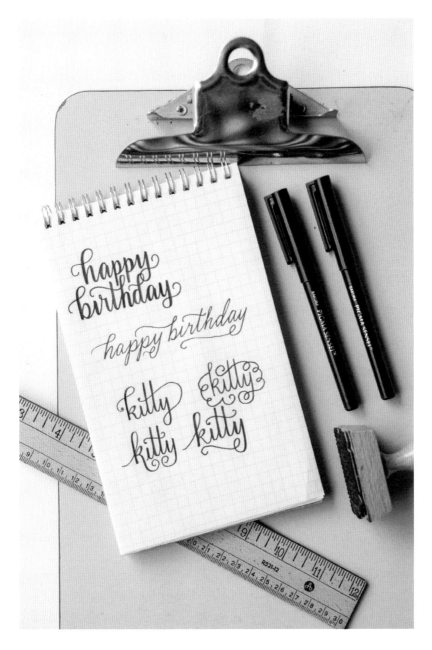

There is no right or wrong. Keep in mind your slants, make sure there is repetitiveness within the word, and see that each stroke almost has a mirror stroke, even if it's in another letter. As long as there are repetitive strokes throughout the lettering, it will be visually pleasing to the eye, since our eyes love seeing double. The more doubles, the better. In the example below, "Type & Typography," the descending loops on the y's, p's, and g's, as well as the cross strokes for the t's, create mirroring and repetition.

For example, "typography" and "alphabet":

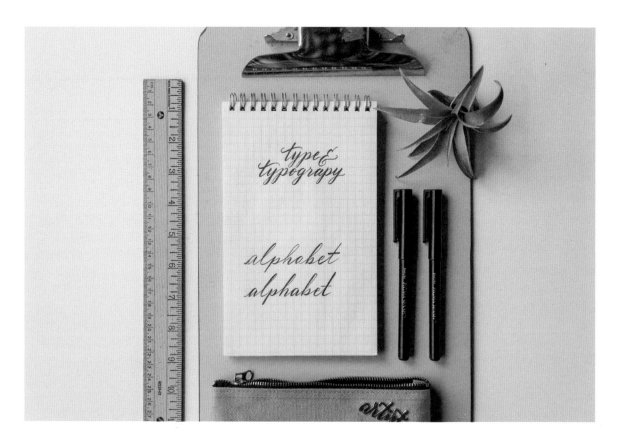

To create a more calligraphic look to your lettering, you must add weight to some of your strokes. Be very particular and selective about this, making sure the weight is placed in the right spots within the letter to ensure, once again, balance. Take a look at the two examples above of "alphabet." The lettered "alphabet" on top does not have a uniform look since weight is placed on various strokes, while the one below places weight on the correct strokes, creating a good and even appearance.

Why Hand Lettering Is Easy; *Try It!*

Whenever I letter, I feel like I am drawing. Every stroke is like painting a picture, and instead the picture is a word, a quote, somebody's vows, a baby's name, etc.

Some may feel pressure or nervousness when trying hand lettering for the first time due to potential mistakes and the time and effort it would take to correct it. Here are three methods that help me alleviate the pressure.

1. I sketch profusely until I have a design that I love. Also, it's important to sketch according to the shape of the item I am lettering on. If your mirror is a rectangle shape, sketch in a rectangle format. If it's a circle, sketch in a circle format. I always have on hand reference of the fonts and typefaces I want to use, and I practice the script I am creating over and over until I can place it into my sketch perfectly.

2. I know what to use, and how to use it, to sketch on the surface I'm working on, be it wood, glass, mirror, or chalkboard. Before I go in with the permanent or temporary medium I'm using for the specific piece, I make sure I have a good sketch on the surface before I lay down that first bold stroke. Knowing what tool to use during the sketching stage and what tool to use to then letter each surface is key.

3. I know how to correct or fix my errors if needed. When you aren't afraid to make mistakes and you are well prepared with your practice sketches on paper and your sketch on the surface, you will feel confident to start lettering beyond paper.

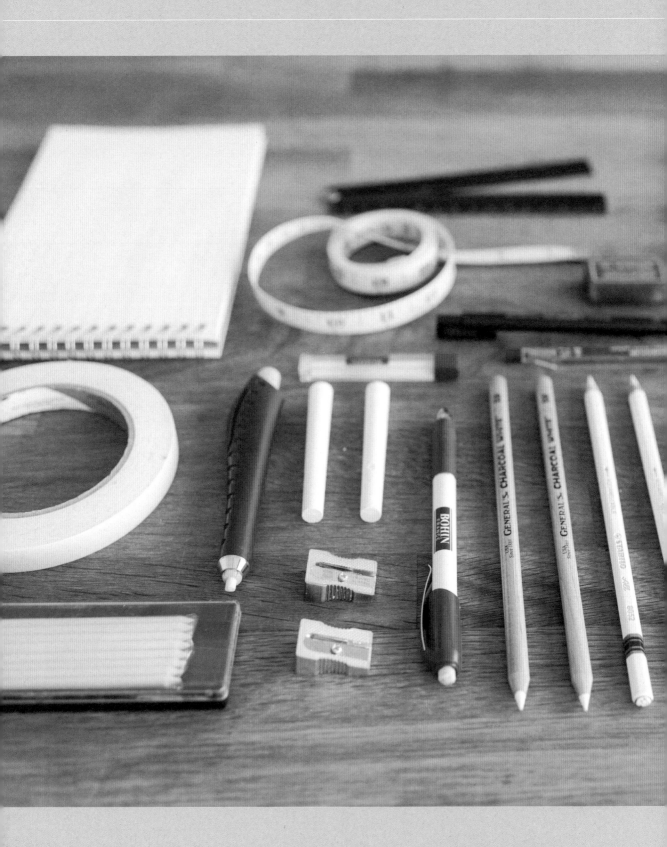

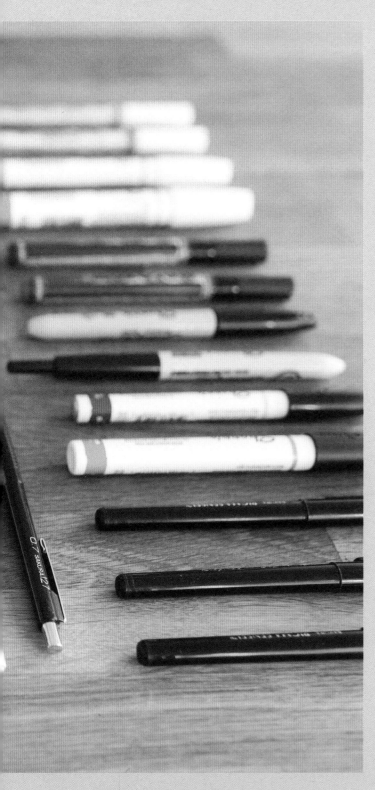

CHAPTER 2

EXTRAORDINARY TOOLS

I have always had a fascination with writing apparatuses. When I was younger, it was more of a Hello Kitty and pencil crayons variety, but as I grew older, I became interested in mechanical pencils and extra fine point black ink markers. The common thread among these materials is that with any one of these tools in my hand, I could create something from scratch—they allowed me to share my ideas and thoughts. I could spend hours trying and buying new pens and markers, as well as learning new techniques.

I am also fascinated with rulers, compasses, erasers, sharpeners, utility knives, and all different types of tape—masking, painting, and double-sided. My obsessions don't stop there—I am super interested in different mediums of paint, acrylic, gouache, watercolor, chalk pastels, chalk, ceramic markers . . . the list goes on. I like to discover new mediums and tools and think about how I can incorporate them in my projects. From that question alone, creativity usually blossoms.

Here is a list of the items in my toolbox, broken down into the two different stages of my creative process: a) Sketching stage (a lengthy process, done on paper) and b) Execution stage.

Tools for the Sketching Stage

MECHANICAL PENCIL

I have not used a regular pencil since discovering the mechanical pencil. There is no sharpening or pencil shavings to deal with, which saves you time, and you always have a sharp point to create a perfectly neat sketch.

ERASER

Very necessary for sketches. The black Factis eraser is my go-to. It is made of soft rubber that is extremely effective at fixing errors on paper. I especially love using it to correct errors on chalkboards. It removes chalk without leaving white eraser streaks or bits behind; perhaps the black eraser bits are camouflaged on the chalkboard.

GRAPH PAPER

I always sketch on graph paper—it literally keeps me in line! It's awesome for spacing and keeping everything the same height and width. You can draw slants easily when you practice cursive and script, and it's great for drawing shapes and placing decorative elements so that it's centered, which is ideal for design and composition. I find graph paper as comforting and important as my daily cup of tea.

RULER

Lettering is made up of a lot of lines, especially straight lines, so a ruler will come in handy. I love to freehand my lettering, which is easier to do on graph paper (because of the lines). However, in the beginning, use a ruler to get your letters spaced well and looking sharp. Let it be your crutch for as long as you need. There is no shame in the lettering game; it's whatever you are comfortable with!

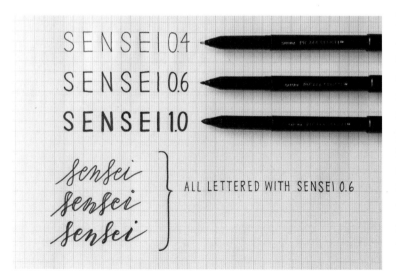

ALL LETTERED WITH SENSEI 0.6

PIGMA SENSEI PENS

Although not a total necessity for sketching, I love to keep these pens on hand, in all three sizes. Size 0.4 is great for precise lettering, with its fine tip; I also like to use this pen to sketch and illustrate basic font. Size 0.6 is great for writing and lettering script—it has thicker, bolder lines with more weight that look great in cursive. Size 1.0 is used for coloring in letters and thickening cursive script.

Tools for the Execution Stage

There are two key factors that will determine your choice of lettering tool: 1. The surface you are lettering on, and 2. Whether you would like it to be temporary or permanent.

Here are my three must-have tools, which are suitable for all projects:

STABILO ALL PENCIL, WHITE

My dream tool. It is one I cannot live without, one I keep thirty extras of in my drawer, one I refuse to throw out even after it has been reduced to an inch tall. Needless to say, I'm obsessed with this tool. Because of the pencil's waxy texture, it's an absolute must for anyone who would like to letter on paper, glass, metal, mirror, chalkboard, marble, etc. Not only can it stick to all these surfaces, it is also watersoluble and can be removed when rubbed with water. I use this pencil to sketch designs onto surfaces before

I introduce more permanent lettering. This dream tool allows you to create even and balanced spaces and sketch your script to near perfection; it allows you to be fearless. It has changed my lettering game, and I'm 100 percent confident you will find 101 uses for it, as I have.

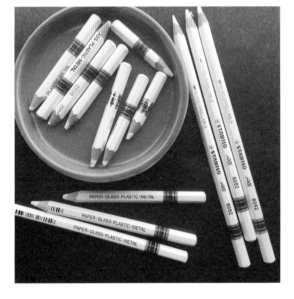

MASKING AND PAINTERS TAPE

I became obsessed with tape in my first year of college, when we were creating a geometrical pattern with gouache on a cold press illustration board. I was able to paint the most perfect lines by using tape as a ruler instead of a steady hand. Since then, I've been using tape as rulers and guidelines when it comes to mapping out signage and creating composition. This ensures balance within my piece and neatness. Tape will make sure all your letters are the right height. It creates a removable border so you won't letter or draw too close to the edge of your canvas. It is especially helpful as it is adhesive, since it is a ruler you don't have to hold! As it is removable, you also don't have to erase any guidelines. I haven't created a single piece of signage or art without the assistance of tape, and that is the honest truth, from large-scale seating charts that are six feet tall to smaller door signs that are 4 x 5 inches. It will make your life so much easier once you start executing your design.

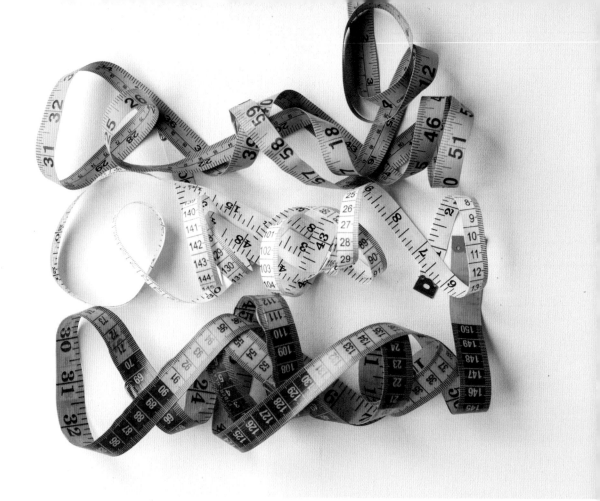

MEASURING TAPE

Use soft tape of the sewing variety that is used by seamstresses; don't use the harder measuring tape that contractors have. Why not a standard ruler, you ask? Most of the surfaces I letter on are framed, and sometimes a ruler doesn't fit into the frames if it's too long or too short. On the other hand, soft sewing measuring tapes can easily measure odd-shaped ovals and frames, like baroque mirrors. Measuring tapes are also longer than your typical flat rulers, measuring up to 60 inches in most cases. It's light, easy to carry around, and not awkward for on-site work. I usually drape it around my neck while working. Keep it on hand all the time during the sketching stage as you'll need to use it to double check your measurements, balance, and spacing while you work on the lettering.

Honorable Mention: Easel

Almost every piece of signage I create that is larger than 11 x 14 inches requires an easel. Besides not having to lean over my art, I can stand back and objectively see if my work is balanced. I step back periodically throughout my work process to check if the lines are straight, if the weight is balanced throughout the letters, and if the words read well from both near and far. Easels are a good investment if you plan on creating signage regularly. They can be adjusted to stand higher or lower so you don't have to strain your back or stretch your arms to create the perfect lettering. They are also a pretty way to display your signage for events and parties.

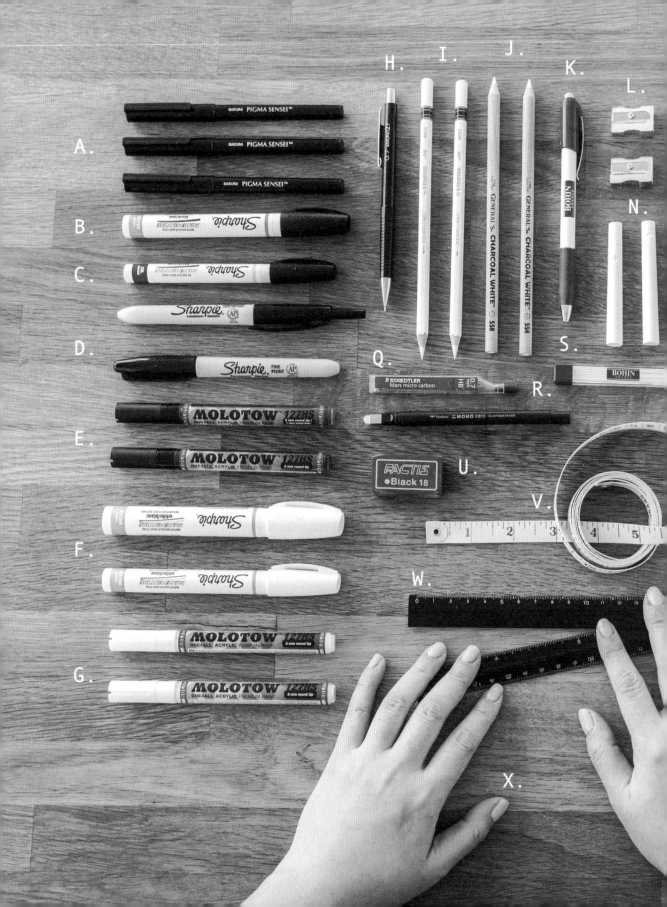

Tools for Each Surface & How to Remove

Here are the specific tools to use for different surfaces during the two stages: the sketching stage and the execution stage.

For each surface, I list the tool used for the sketching stage, which is removable, and the tool for the execution stage, to create the final look. I also include other tools that are more temporary or permanent mediums.

A. Pigma Sensei in 0.4, 0.6, 1.0
B. Sharpie water-based paint marker, black
C. Sharpie oil-based paint marker, black
D. Original Sharpie marker in fine point and ultra fine point
E. Molotow acrylic paint markers, black, extra fine and wide tip
F. Sharpie water-based paint marker, white
G. Molotow acrylic paint marker, white
H. Mechanical pencil
I. Stabilo All pencil, white
J. General's Charcoal, white
K. Bohin France mechanical chalk pencil
L. Sharpener
M. Allary chalk cartridge refills
N. Regular chalk
O. Allary chalk cartridge
P. Masking tape
Q. Lead refills (for mechanical pencil)
R. Tombow Mono Zero eraser (for tight spaces)
S. Bohin France mechanical chalk pencil refills
T. Graph paper
U. Factis black eraser
V. Measuring tape
W. Ruler
X. Your hands

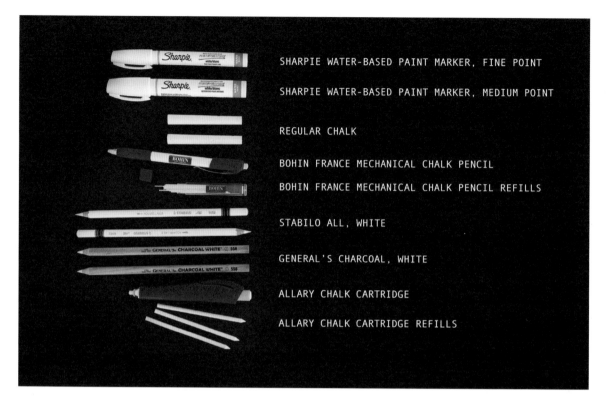

SHARPIE WATER-BASED PAINT MARKER, FINE POINT

SHARPIE WATER-BASED PAINT MARKER, MEDIUM POINT

REGULAR CHALK

BOHIN FRANCE MECHANICAL CHALK PENCIL

BOHIN FRANCE MECHANICAL CHALK PENCIL REFILLS

STABILO ALL, WHITE

GENERAL'S CHARCOAL, WHITE

ALLARY CHALK CARTRIDGE

ALLARY CHALK CARTRIDGE REFILLS

REAL CHALKBOARD

Sketching Medium

Hands down, the Bohin France mechanical chalk pencil, another seamstress's tool, is one of my best discoveries and investments. When I discovered this tool, it felt like I was ten again, when I first discovered the mechanical pencil of the lead variety. It dispenses chalk with a sharp, fine point for precision, and there's absolutely no or very little mess. No sharpening required. It is not as white as real chalk, which is actually great for sketching. This tool is a must-have if you're creating detailed chalkboard signage, such as seating charts; otherwise, you will be doubling your time sharpening regular chalk to letter all those names.

Temporary Medium

There are great options for creating temporary writing on chalkboards, one of them being traditional chalk! I, however, never use chalk unless I have large letters or strokes to color in. I always prefer a finer and smaller point for precision and less mess! Besides having real chalk on hand, I also use General's Charcoal White 558, which can be sharpened and gives a really clean, white look. The Allary Chalk Cartridge Set, which comes with white and colored chalk, acts like a mechanical pencil, but the chalk is much larger in circumference.

Semi-Permanent Medium

For a medium that will make a mark on a chalkboard that you can touch without erasing, I use my favorite, the Stabilo All. If you letter over your sketch with this tool, your signage will stay put until you take a wet towel to it.

Permanent Medium

If you don't want the art to come off with water, go in the direction of an acrylic or oil paint marker. Acrylic and oil paint applies as a liquid but dries as a solid plastic. This is especially useful if you want some sections of your chalkboard written in permanent letters and other sections in temporary writing. While a wet cloth would wipe away any temporary chalk wording, lettering in acrylic paint will stay intact. My go-to pens are the Sharpie oil-based paint marker or the Molotow acrylic paint marker. Both varieties have nib variations for sizing of letters. Using paint markers creates a super bright contrast between the board and the lettering, which is usually great for lettering menus.

Removing Mediums

Bohin France chalk pencil: Eraser
Stabilo All: Water and cloth
General's Charcoal pencil: Water, cloth, Mr. Clean eraser
Allary or regular chalk: Water and cloth
Oil-based or acrylic paint markers: No erasing! Repaint error with chalk paint or repaint whole board.

FAUX CHALKBOARD

Sketching Medium

Because faux chalkboards have a slippery surface, the most ideal tool/pencil to use will be the Stabilo All. Real chalk does not stick to the surface of these faux chalkboards as the boards do not provide any grit for the chalk to hold on to. The Stabilo's waxy texture does the trick nicely.

Temporary Medium

Sharpie water-based paint marker in white is my go-to for working on faux chalkboards if I want temporary lettering. Since it is water-soluble, mistakes are easily corrected. The Sharpie paint marker has a great consistency and good pen flow.

Permanent Medium

To letter permanently on faux chalkboards, use the same tools as you would for a real chalkboard.

Removing Mediums

Stabilo All: Water and cloth
Sharpie water-based paint marker: Water, cloth, Mr. Clean eraser

Oil-based and acrylic paint markers: No erasing! It's really hard to remove these mediums from a faux chalkboard, which is why a tight surface sketch is advised in this case. Removing oil and acrylic paints from a porous material usually requires some sort of sanding and/or chemical agent. I would not go beyond nail polish remover. Try it in an inconspicuous area before testing it on your artwork.

BLACK FOAM CORE

Sketching Tool
Bohin France chalk pencil is the preferred tool for sketching on this paperlike surface that poses as a chalkboard.

Temporary Medium
I suggest the Bohin France chalk pencil or perhaps the General's Charcoal pencil in white.

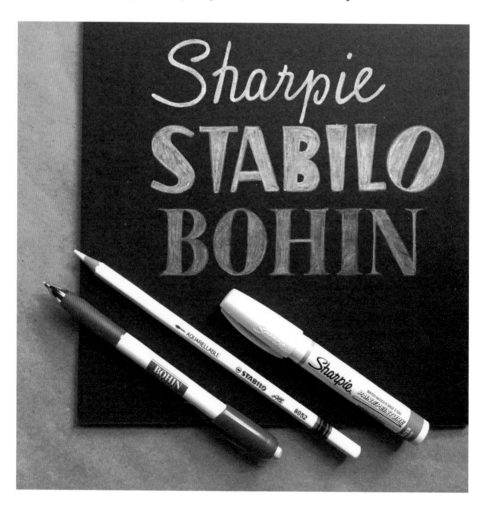

Permanent Medium

Lettering permanently on foam core chalkboards doesn't require heavy-duty paint markers since the surface is like paper. The Stabilo All pencil will create lettering that won't smudge when touched.

Removing Mediums

Bohin France chalk pencil: Eraser

General's Charcoal white pencil: Eraser

Stabilo All pencil: Cannot erase! Due to its waxy texture, it sticks too well to the surface of foam core. Erasing will smudge it, and it never really disappears. So, be careful!

B. For Mirror And Glass

Both mirror and glass surfaces are nonporous, so any type of medium essentially sits on top of the surface and does not seep or penetrate in, making it easy to remove.

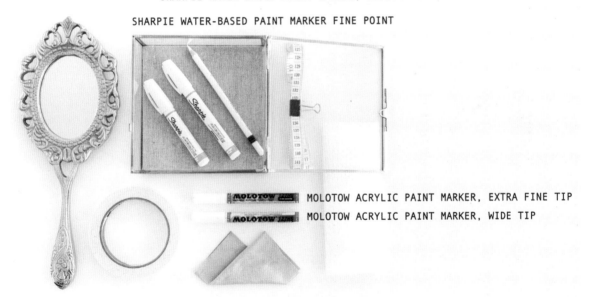

STABILO ALL, WHITE

SHARPIE WATER-BASED PAINT MARKER, MEDIUM POINT

SHARPIE WATER-BASED PAINT MARKER FINE POINT

MOLOTOW ACRYLIC PAINT MARKER, EXTRA FINE TIP

MOLOTOW ACRYLIC PAINT MARKER, WIDE TIP

Sketching Tool

I use the Stabilo All pencil in white to sketch on glass and mirror. This medium sticks and shows up well on the surface, making it really easy to see your design and lay down the ink during the execution stage.

Temporary Medium

My go-to pen for temporary lettering on glass and mirror is the water-based Sharpie paint marker in fine point. Ninety percent of my mirrors and glass signage is done with this marker. It has a consistent opaque white color. Sharpie provides three sizes for the water-based paint marker: medium point, fine point, and extra fine point. I always have all three on hand, but I use the fine point the most. I also keep ten or more extra markers with me at all times. This marker dries quite quickly, about 30 to 45 seconds, which can be good or bad. If the paint has dried and you go back later on to fill in the weight for the strokes, you might run the risk of scratching off the already dried lettering and creating a mess. Therefore, I usually thicken the strokes as I go, while I draw each letter. This is the perfect marker to use on rental items, as removal is easy. I love using the Sharpie paint marker for my seating charts because its fine tip creates neat lines that are still thick enough to be legible.

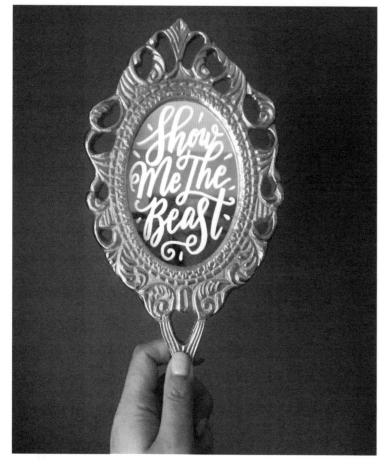

Permanent Medium

Sometimes, you want to create a piece that will withstand the test of time—perhaps as a gift or souvenir from a wedding. For this occasion, I use Molotow paint markers, which come in wide tip or extra fine tip sizes. These acrylic paint markers are pretty durable once they dry and have quite the staying power. Molotow also has a variety of colors. Keep in mind that some colors show up better than others, and contrast should be taken into consideration when lettering in color. Once again, because glass and mirror surfaces are nonporous, no medium is ever permanent. These just hold on better than others.

Removing Mediums

Stabilo All pencil: Tissue or microfiber cloth
Sharpie water-based paint marker: Scratch off with a plastic card (for example, a credit card) or use warm water and a cloth
Molotow paint marker: Windex, nail polish remover

C. FOR WOOD

Wood, I feel, is the trickiest surface to work on as it is very unforgiving. You must be able to sketch well on wood and have a well-thought-out design before execution. Also, I suggest always testing your tools on the back of the surface first. Wood can be varnished, raw, painted, waxy, etc., so it's good to know what you are working with. This way, you will know how to handle the surface and remove the lettering.

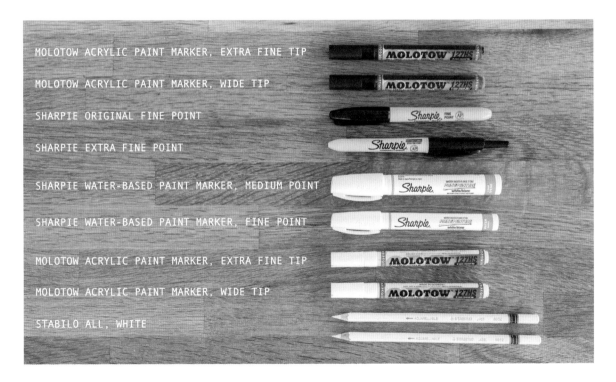

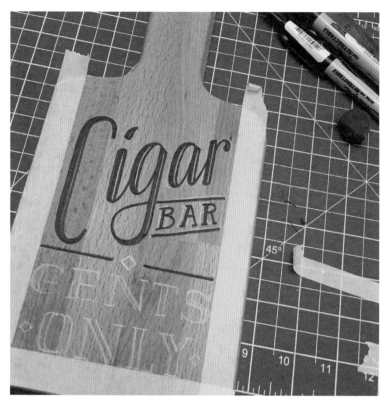

Sketching Tool

If your wood is rough and darker in color, I suggest the Bohin France mechanical chalk pencil. If your wood surface is slippery, I suggest the Stabilo All pencil.

Medium

I use many different mediums for wood. Acrylic paint is a great choice as it will show up nicely and adhere to most surfaces. The consistency of acrylic is also controllable and that is good when a good grain is present. There's always a chance that regular paint would seep and bleed into the wood, so the thicker viscosity of acrylic may prevent seepage. Note: anything lettered with a brush as opposed to a marker takes longer to execute.

As mentioned, it's always a great idea to test out your medium on the back of the wood surface before you go ahead with the final execution so you can see how the surface and medium work together.

Note
Any type of paint that is laid on wood is pretty much permanent, since the wood surface absorbs the medium.

My best tools for wood are:

1. Sharpie oil- and water-based paint markers

2. Acrylic paint and a paintbrush

3. Molotow acrylic paint marker

It is hard to correct errors on wood. Once your pen/paint has touched the surface, it gets into the grain and is impossible to remove without sanding or using a harsh substance. So, sketch well and work mindfully. As my daughter learned from kindergarten: "Haste makes waste." Wise words!

Removing Mediums
Bohin France chalk pencil: Eraser
Stabilo All pencil: Eraser or cloth with water, spot remove (do not drag the cloth across your art/signage)

In general, removing any type of paint laid on wood is going to be extremely tricky. Even with removal of the top layer, if the paint has seeped into the grain of the wood, ghosting or a leftover image may still be present. If it's a small spot, consider tackling the area alone. Can you color in the mistake with a pencil crayon or potentially hide a scratch by rubbing a walnut against the area (rubbing oil-rich nuts have fixed many of my scratched wood issues in the past)? Otherwise, sanding may be the only thing left to do. If your wood is painted, you can consider painting a fresh coat to start over.

QUICK REFERENCE GUIDE FOR WHAT TO USE & WHEN TO USE IT!

SURFACES	SKETCHING	TEMPORARY	PERMANENT
CHALKBOARD	Bohin chalk pencil	Stabilo Aquarellable or Real chalk	Molotow acrylic paint marker Sharpie oil paint marker
FAUX CHALKBOARD	Stabilo Aquarellable	Stabilo Aquarellable	Molotow acrylic paint marker Sharpie oil paint marker
BLACK FOAM CORE MOCKBOARD	Bohin chalk pencil	Bohin chalk pencil or General's Charcoal	Stabilo Aquarellable
RAW WOOD	Bohin chalk pencil	N/A	Molotow acrylic paint marker Sharpie oil paint marker
STAINED/PAINTED WOOD	Stabilo Aquarellable	N/A	Molotow acrylic paint marker Sharpie oil paint marker
MIRROR	Stabilo Aquarellable	Water-Based Sharpie paint marker	Molotow acrylic paint marker
GLASS	Stabilo Aquarellable	Water-Based Sharpie paint marker	Molotow acrylic paint marker
CLEAR ACRYLIC	N/A	Water-Based Sharpie paint marker	Molotow acrylic paint marker

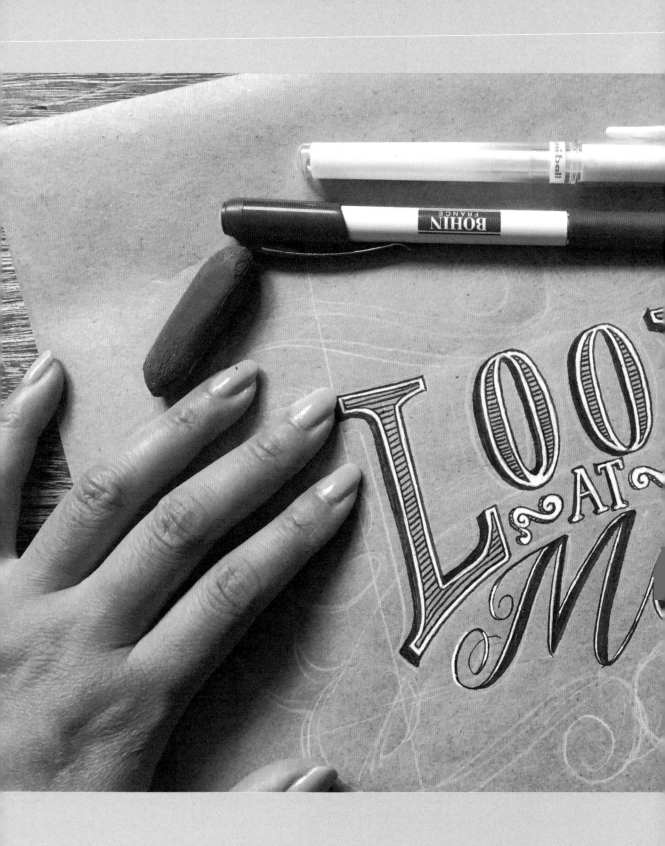

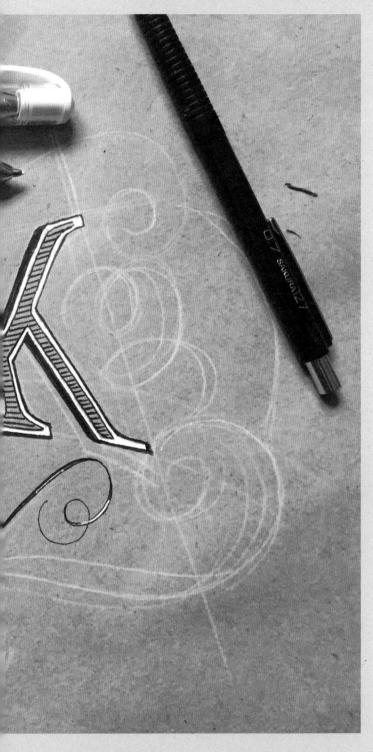

CHAPTER 3

COMPOSITION & DESIGN

This is the most creative chapter in the book. Here, we will explore ideas of what and how we can create a wonderful piece of hand-lettered signage.

By this point, you should already be familiar with the tools you need to use to letter on each surface. Now, let's move on to design, which is one of my favorite parts of the process! Make no mistake, the ideas you sketch out during the preliminary design stage are of utmost value! What starts off as scribbles has the potential to become a masterpiece; you may even create something that, while not useful for the project at hand, would be perfect for another piece in the future. Every minute you dedicate to sketching, the more you put into your creativity bank. This bank is worth more than the finished products, as it holds the ideas for your next big marketing campaign. Remember: all sketches are valuable! Sketching also allows you to practice your lines and designs. So, sketch often, and practice a lot. There is no perfection or an end to sketching, and there is always room to grow.

Spotlight Words

Composing signage is very much like putting on a show. Figure out the words you want to put under the spotlight, and which words will play the role of the much needed but less important backup dancers. Spotlighted words refer to the lead or most important elements in your quote. You want to make sure these words have more of a presence by highlighting them with decorations or using special fonts; also consider the size of these words. Spotlighted words should jump out at the viewer and communicate the message of the sign instantly. They will tell a story, even if the viewer doesn't read the whole quote. In contrast, the other "backup dancer" words should be smaller in size, with more basic and simple fonts.

Placement and spacing is very important, as is the balance of the word within the sign you are creating. Look at the space you have been given. How will you lay out the words? What size will they be? Consider all of this when you sketch your ideas.

How to Choose Fonts

Consider the meanings of the words when you choose your fonts. Reflect on the definition and feeling of the word and how it is being expressed in your sign. Is your piece about celebration? Is your piece about overcoming struggles? Is your piece a love letter? These questions will help you decide on a typeface.

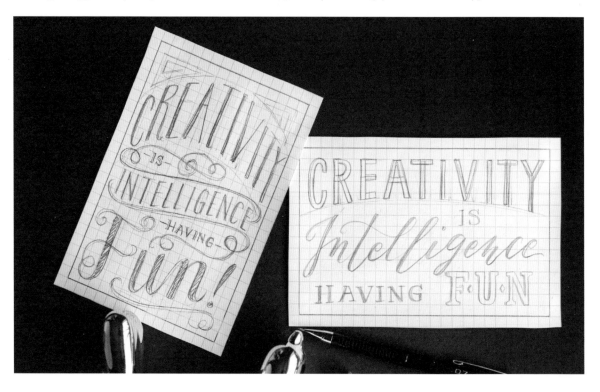

Example 1:

Let's start with this quote:

"Creativity Is Intelligence Having Fun"

Let's say your surface is a simple rectangle. Identify your spotlight words—I feel that "creativity," "intelligence," and "fun" are all important in this piece. The words "is" and "having" will be the supporting extras.

Since this piece is about creativity, I chose three to four different fonts. Using different fonts in one piece creates visual buzz and requires the viewer to look at the art longer in order to take in the words. When I create signage, I always want the viewer to feel like they are looking at a piece of art and not necessarily signage at all.

Example 2:

For big events, such as weddings, unless the aesthetic is fun and whimsical, I would stick to a maximum of two to three types of font styles in order to keep a level of elegance and style. Usually, one font is in cursive and script, while the other is more basic, meant for backup words.

"Welcome to Kate and Ryan's Wedding"

Note the mirroring in the strokes and style between the words "welcome" and "wedding" and the words "Kate" and "Ryan." The more repetition or mirroring in a piece, the easier it is on the eyes, in my opinion.

Finding the Center

Centering your words is extremely important when composing your design. It may seem obvious, but let me emphasize that this is critical! Words that are off-center can throw everything off for the viewer, so be really mindful of this. First, I figure out which letter is at the center of a word.

For example, "ALPHABETS."

Since the word "ALPHABETS" consists of an odd number of letters, the "A" in the middle is the center of the word. Although people usually write from left to right, begin by laying the letter "A," in the center, then continue to lay the

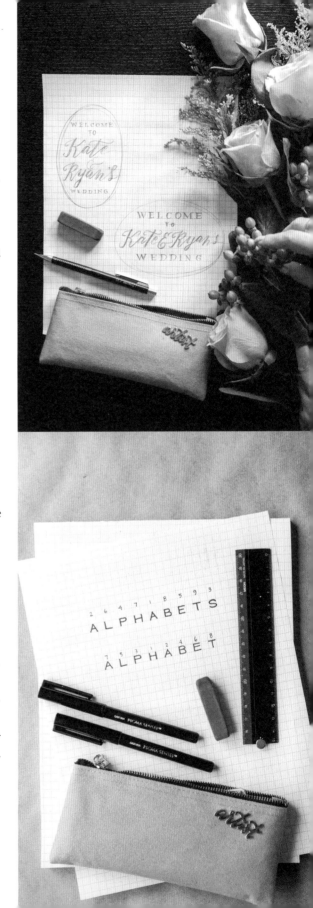

Note

If you don't have a measuring tape on hand but need to find the center of your signage, here is a neat trick I use. It's not 100 percent accurate, but it's close. I take each index finger and place them on the outside edges of the signage you are lettering on. I then close my eyes and run my fingers together until they meet, which is usually right in the center. (I'm not sure why closing my eyes is important, but it just feels right!)

other letters down on either side to make sure the lettering is balanced and centered.

However, do take note of the letter "I," which is narrower, and the letters "M" and "W," which are wider. You get the point!

For words with an even number of letters, the center point would be the space between the two central letters. To measure, I place a narrow object or marker (such as a pencil) on the center of the line and draw the two central letters on each side of the space. From there, I work outward until the word is complete, using the same object or marker to measure out the spaces from one letter to the next.

Borders, Mapping & Breathing Room

Breathing room in between letters and words makes signage easier on the eyes. The spaces around the words are as important as the words themselves! When things are too close together, it creates a busyness that may be distracting. This is especially the case when it comes to lettering on mirrors. It is always encouraged to fill a space fully with letters that command and dominate the surface; if your words are not large enough, they will simply float within your piece as if they do not belong. Should you find yourself with the dreaded floating words, you can still fill the empty space with illustrations or flourishes. However, if you map, sketch, and plan your space well, floating words should never be an issue.

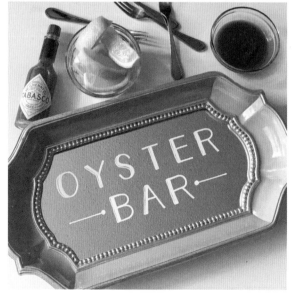

Always create a border around your surface before you start your signage. Once you have a pencil sketch, use masking or painter's tape to mark and map out a border. This delineates a fixed area, allowing you to letter within your surface, ensuring that your words will never get too close to the edge. Mapping out a confined space within a border also provides you with a center of the piece, allowing you to create balance and align your words. Knowing that you can letter edge to edge without going too far is the comfort that masking tape brings!

Even if your surface is not a perfect shape like a rectangle or square, you should still create and start every piece with a border. I also use tape to determine the height of all my letters, just so I don't have to hold up a ruler to keep my letters in line.

Here is "Happy Birthday Natalie" sketched out on graph paper. I have mapped out a rectangle in an oval shape.

Note, again the mirroring in the strokes in "Natalie." These strokes touch the top and bottom of the tape, so when you remove it, the lettering should be centered, balanced, and beautiful.

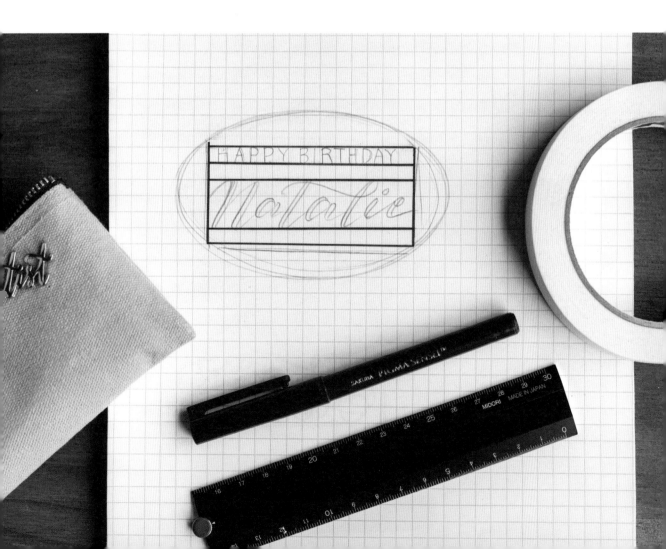

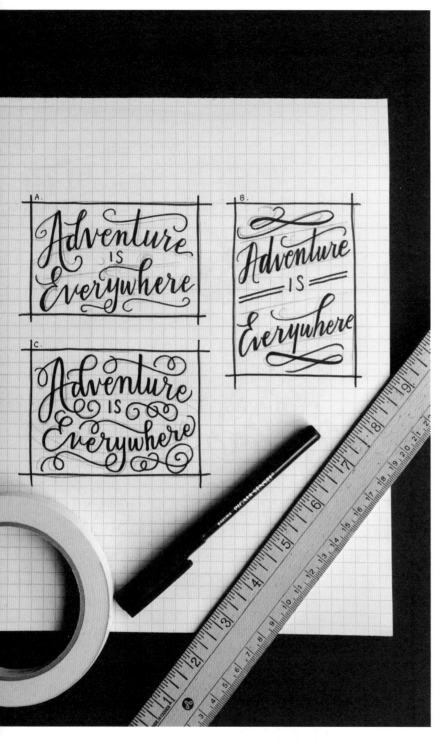

Shapes & Angles

I like to create visual interest by lettering type that follows certain shapes and angles.

Consider the quote "Adventure is Everywhere," lettered on a mirror that is 10 x 16 inches. Take a look at the many possibilities and options:

A. Horizontal format
"Adventure" and "Everywhere" are considered spotlight words, while "is" plays a supporting role. "Adventure" follows a convex curve at the top, "is" is placed in the middle in smaller and plainer type, and "Everywhere" is lettered at an angle.

B. Vertical format
All three words are at an angle, but "is" is smaller and the spotlight words are larger.

C. Horizontal format
"Adventure" follows a convex curve at the top, "is" is placed in the center in a basic font style and smaller size, and "Everywhere" follows a concave line, creating the overall shape of an oval.

As you can see, there are many interesting options, just by lettering three words according to different layouts!

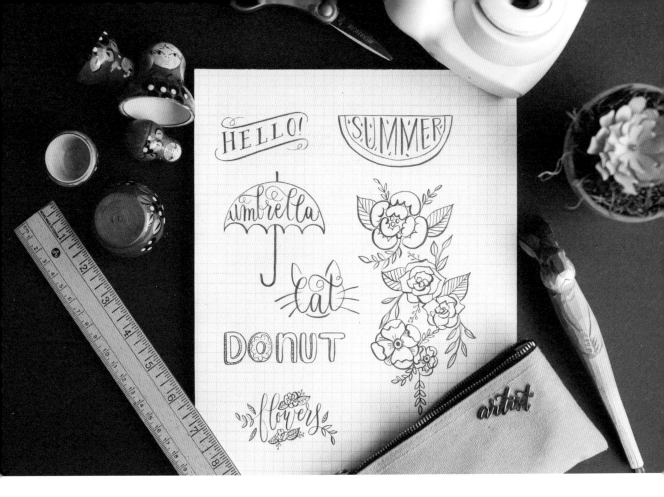

Design & Decoration

Although I feel like I have a signature style, I thrive on using new fonts and discovering the right reasons to use them. Along with lettering, I sometimes incorporate additional illustrations and decorations into my signage. For weddings, use florals and flourishes as they are fitting for the occasion. Florals are always useful to balance out a piece. I also like to use illustrations within the lettering to create an even more stylized and tailored sign. Sometimes even the addition of simple lines can make a piece of signage that much more interesting. Scrolls and banners are great ways to decorate a word and make it stand out.

I have included some simple line drawings here to help you get started. Most of the time, these line drawings are created with pen; however, if you dare, you can paint illustrations on mirror, glass, or wood with gouache or acrylic paint. For chalkboards, there are a variety of colored chalk pastels that you can use to create really pretty flowers—and don't forget leaves! I love drawing leaves as much as I love drawing flowers.

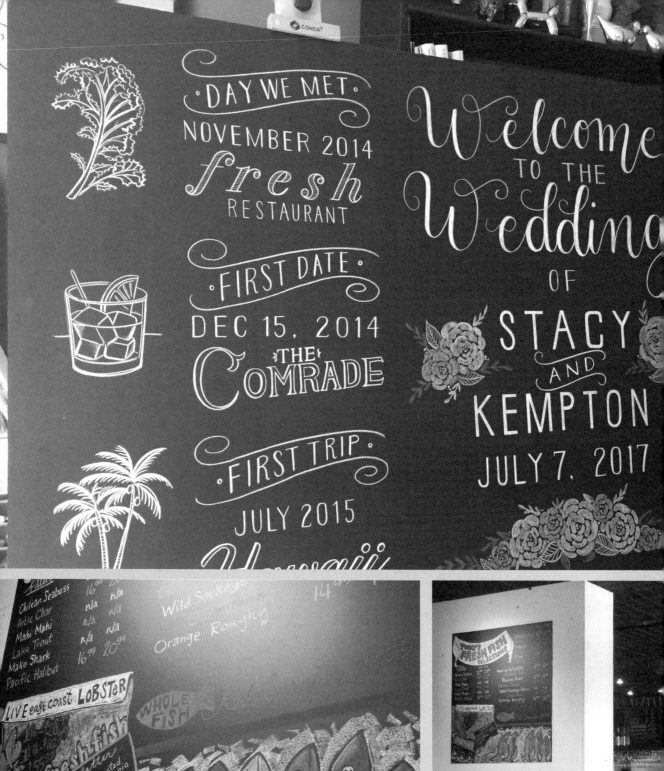

·DAY WE MET·
NOVEMBER 2014
fresh
RESTAURANT

· FIRST DATE ·
DEC 15, 2014
THE COMRADE

· FIRST TRIP ·
JULY 2015
Hawaii

Welcome
TO THE
Wedding
OF
STACY
AND
KEMPTON
JULY 7, 2017

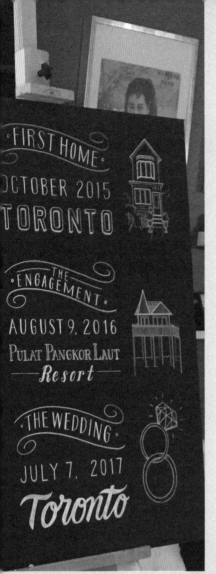

CHAPTER 4

SURFACES

I have been hand lettering for as long as I remember, but always on paper. One of my favorite things to letter were envelopes for Christmas cards. Every year, I always thought, *What am I going to do this year?* Since an address had to be written on an envelope anyway, what if I made the address beautiful? Would the postman take a second glance in the sea of Christmas cards in December? I continued to use my lettering to create art prints and cards, but it was only when I started lettering on chalkboards at the bar I used to work at that I allowed myself to think beyond paper, to create functional and purposeful lettering, just like the necessary addresses on cards.

I used to letter the daily special at a restaurant every day—it was my job, and pleasure, to do so. There I was, already lettering on a surface other than paper, unaware that I would one day be lettering on glass, mirror, porcelain, acrylic, wood . . . and anything I could get my hands on. I was interested not just in flat surfaces, but also in things like shells, leaves, tiles, lemons, and lightbulbs. Everyday items called out to me to turn them into something special, creative, and beautiful. And so I did. I answered their calls, and, in turn, I found my own calling.

The idea is to look at otherwise mundane objects—whether found easily in your home, at the dollar shop, at the home hardware store, or even on the side of the road—and see how they can be transformed, simply by lettering on them. As you shop, open your mind to the possibilities of how lettering can give an item purpose and beauty. When you flip that switch in your mind, the ideas will present themselves. Make beautiful things even more so with a lovely quote, refresh an antique mirror by using it as a canvas for a creative project, personalize an item by lettering a person's name on it, style events with signage These objects will work double duty as sentimental decoration while serving a functional purpose. They are truly everyday things—sometimes new, sometimes repurposed or upcycled, and always lettered and extraordinary.

Despite the wealth of possible surfaces out there, let's focus on four very common surfaces: wood, chalkboard, glass, and mirrors.

Wood

Wood is one of my favorite surfaces to work with. It can produce many different looks depending on the tone and colors of the natural wood, the different shapes and sizes the pieces come in, and its ability to be painted on or stained. This makes wood a chameleon, an amazing blank canvas for creative minds.

Logs sliced into plates can be used as table numbers at a wedding, creating a romantic and rustic feeling—especially with pretty script lettering. Wood blocks or any woodcut typeface can be made into food signage for a little one's lumberjack party. When applying different lettering styles to the same surface, you set a different vision and mood.

Wood can be found in nature, all around the world. I always look for unique wooden items when I am on vacation, such as lovely wooden toys, souvenirs, or kitchen tools. Your local home renovation store will offer sheets of plywood that can be stained or painted to any color your heart desires. You can find wooden treasures at thrift and dollar shops or at high-end décor shops. Then, take the pieces home and make them more beautiful with your creative lettering.

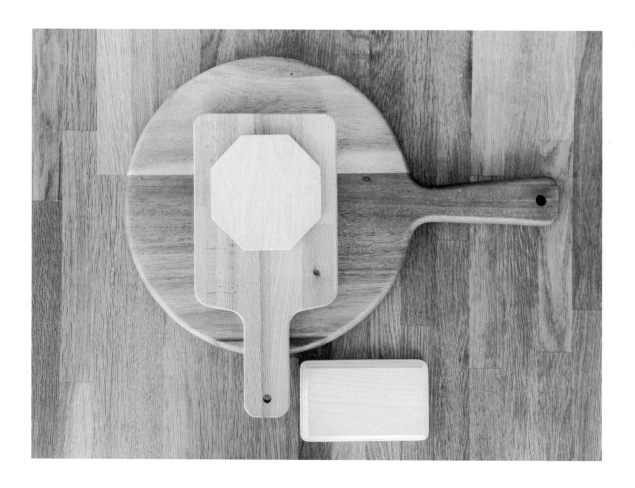

Chalkboard, Faux Chalkboard & Black Foam Core

Chalkboards take me back in time to the days when I was a schoolgirl, when chalkboard erasers had to be cleaned every day after school by smashing them together outside the classroom, creating clouds of dust that, hopefully, would drift away in the wind. Those days are long gone. When I work with chalkboards now, it's pretty much mess-free!

Chalkboard is one of the most versatile and easiest surfaces to work on. Depending on the look of the chalkboard, it can be a great detail for rustic and earthy themes; if placed in a beautiful vintage frame with the right lettering, it can be elegant and romantic as well.

The best part about chalkboard is the ease with which you can erase mistakes and revise your design quickly.

Nowadays, even the chalkboard surface has changed. The original chalkboard was a matte, semi-rough surface with grit and tooth, which chalk could actually stick to and be removed with water. However, with the introduction of chalkboard markers, some chalkboard surfaces have simply become a black nonporous surface, with a shiny and smooth surface that does not hold real chalk marks at all. It is very important to know which surface you are working on in order to choose the right tools. Always do a test run on an inconspicuous area to make sure you can erase or remove the medium you are using before you begin.

REAL CHALKBOARD

These have a gritty, matte feel. You can pretty much turn anything into a chalkboard surface—a whole wall in your kitchen, old silver trays, or a bedroom closet door. Anything can become an amazing blank canvas with unlimited possibilities. For an original black chalkboard look, head to your nearest home hardware and paint store, which should offer the spray can format as well as the kind you roll or paint on. I prefer the paint version as opposed to the spray can version, which can get blown away during application; it is also easier to control application of the painted version.

If you are painting a smooth surface, use a roller for a smooth, streak-free look. If you are painting on an odd shape or furniture, use a brush for those tight corners and spaces. I usually apply two thin layers as opposed to one thick layer (that goes for any type of painting, even my nails!). Once the chalkboard surface is dried and ready to use, prime the board by taking real chalk and running it all over the surface, rubbing it in, and then removing it. This preps the surface to be worked on and makes future chalk marks easier to erase.

Faux Chalkboard

These are available in most craft stores, as well as some office supply shops. They have a slippery, smooth feel. Real chalk will *not* stick or grip on to the surface; use chalkboard markers.

Black Foam Core Board

This is imitation at its finest, one of my easy go-to secrets when creating a budget-friendly chalkboard look. For this reason, I like to call this imitation chalkboard a "mock chalkboard"! I use black foam core to create signage that *looks* like chalkboard but is actually just black foam core. Looking for a real chalkboard can sometimes be quite the task, and I like to save chalkboard paint for larger projects such as walls and closet doors, especially if you want to be able to erase and reuse the surface. But what if you just wanted to create a simple, pretty sign for a party? Black foam core is definitely the way to go. Take any frame you already have in your home and remove the backing and the glass. Go to your nearest craft store and pick up a piece of black foam core. Cut it to the size of your frame with a utility knife and mat, insert into the frame, and ta da! However, this is a one-time use; you cannot erase the signage once you have lettered on foam core.

Glass

Glass is widely available and ready to use instantly. There's no preparation besides making sure it's clean, which can be done with a couple of sprays of Windex and some old newspaper. Glass comes in an array of items—glassware, lanterns, vases, windows, bottles, etc. All these items are potential canvases for beautiful projects.

To begin, glass is nonporous, which means mediums applied to the surface can be easily removed as they will not absorb into the surface, as in the case of wood or paper. I find it comforting to know that mistakes can be easily fixed.

Regular picture frames are the easiest to find and letter on. Since they come in different styles, you can easily choose the right format to fit the purpose of your project. Just make sure that the surface is actually glass and not acrylic (acrylic can also be lettered on, but using different methods and tools). Before lettering on a glass from a picture frame, you can remove the back panel and the glass; however, I like to keep the glass within the frame as I letter to reduce the risk of mishaps when I transfer the glass in and out of the frame.

The magic of using a picture frame is that it allows you to create a shadowbox effect if you remove the backing and place items behind the glass to accent your theme. To ensure that the glass stays put within the frame without the backing, apply dots of hot glue around the edges of the frame.

Check out the hot chocolate bar sign, (page 88). Fresh evergreen leaves were used as a design element.

There are so many types of glass that can be used as surfaces for signage: antique windows, stained glass, wineglasses, mini champagne bottles, jewelry boxes, perfume bottles, jam jars, etc.

Mirror

Mirrors are another beautiful surface that can be found anywhere—they are in every bathroom in any home, and they come in a wide range of sizes, from ones that fit in your hand to ones that occupy an entire wall. Because of the vast amount of styles and designs available, finding a mirror that fits your party theme or home décor is really easy.

Mirrors are nonporous as well, so the applied medium will sit on top of the reflective surface and can be removed quite easily. I love working with mirrors for this reason!

Consider all things with a mirrored surface a wonderful opportunity to create something amazing Think ornate gold mirrors from the Victorian era for glamorous wedding affairs, fancy princess birthday parties, and statement pieces in the home.

An addition of the perfect choice of words and lettering will give these antiques a fresh and modern face.

Cleaning & Prepping Your Surfaces for Lettering

The surfaces of all your lettering projects should be cleaned before you start working and sketching on them. If your surface is not clean, the mediums may not stick to the surface well, and you also run the risk of ruining the tool.

For glass and mirror, make sure they are dust- and smudge-free. Use Windex or rubbing alcohol and a newspaper or a paper towel.

For real and faux chalkboard, the surface must be cleaned and prepped for chalk lettering. Use cloth and water.

For wood, ensure that the surface is free of any debris or splinters. If you have sanded a piece of wood, take a damp cloth and wipe it down a couple of times, then let the wood dry. Sawdust from sanding wood ruins the tips of paint markers, clogging them up and making them hard to use again. Use cloth and water.

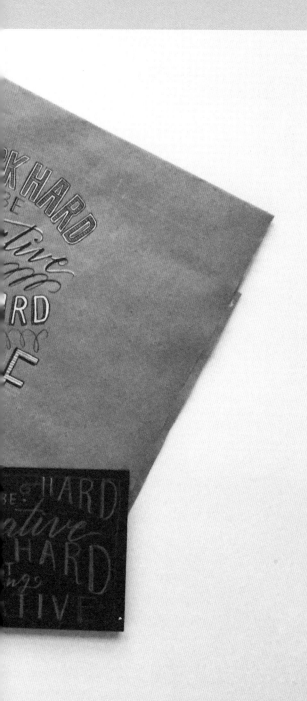

CHAPTER 5

IDEAS FOR LETTERING

Every time I letter a commission, there is always a purpose and a reason, whether it is to welcome guests to a wedding, help them find their way to their table, or instruct them to place their gift into a glass lantern. I like to think of lettering as a lifestyle. I like to incorporate hand lettering into my everyday routine, and I also use it for big and special occasions.

"Work Hard, Be Creative; Work Hard at Being Creative"

This is a quote I came up with and always try to live by. I wanted to be constantly reminded and mindful of this mantra, and since I had the skills of lettering up my sleeve, I decided to create an art piece that spoke to me, that represented me, and that could be passed on to others.

The idea is not to be perfect; rather, the focus is on the action in trying to achieve it. A handwritten note from a loved one, homemade chicken noodle soup, or a scarf knitted by Grandma are essentially the same things. They are labors of love—and they are for the people around you as well as for yourself. I call this movement the "lettering lifestyle," and it has been my regular and routine life for years. I use any and all occasions to personalize gifts and make beautiful things for my family and friends.

Take the time to create something special for someone with the art of hand lettering. As life happens, sometimes a potted plant accompanied with a card that

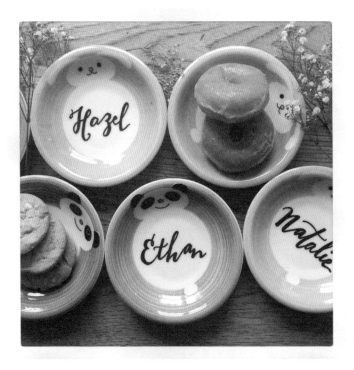

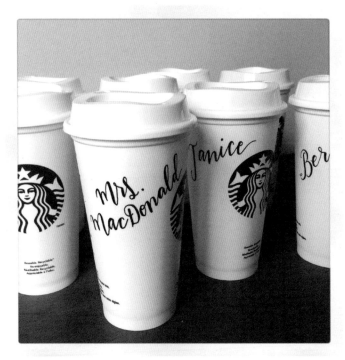

says "I'm sorry" will come in handy. I promise that every time you create a hand-lettered piece, it will be welcomed with gratitude because of the love and effort that went into creating it. There's always a reason to letter, whether as a creative outlet or just a way to bring happiness to yourself and others.

The best part is you can express yourself with words by lettering them onto things other than paper. When you letter beyond paper, you transform the mundane into the magical. For example, take lyrics from the song you love and letter it on an old guitar to create something meaningful for your music room or that friend who loves music. On that note (see what I did there?), think about all the other instruments you can possibly letter on. A cymbal? The skin of a drum? A violin? Instruments are already beautiful works of art, and adding meaningful lettering elevates them beyond just functionality—they also become works of art in and of themselves. A poem, one form of art, can be presented in hand lettering, another art form, and presented on yet another object of art to create the ultimate piece—there are infinite combinations and possibilities!

Here are some examples of what is possible when you hand letter beyond paper. And, remember to take what you've learned from this book, generate your own ideas, and make your own art.

EVENTS & PARTIES

Welcome signs
Seating charts
Dessert signage
Dessert backdrop
Bomboniere table
Photo booth stations
Bar menus
Place cards
Food tags

HOME DÉCOR & ORGANIZATION

Nursery ideas
Recipes
House rules
Fences
Windows
Closet doors
Tables
Mirrors
Chairs
Spices and seasonings bottles
Pantry organization
Gardening signs
Garage organization

GIFTS

Potted plants
Gift baskets
Mirrors
Wine bottles
Wineglasses
Coasters
Jewelry boxes
Coffee mugs

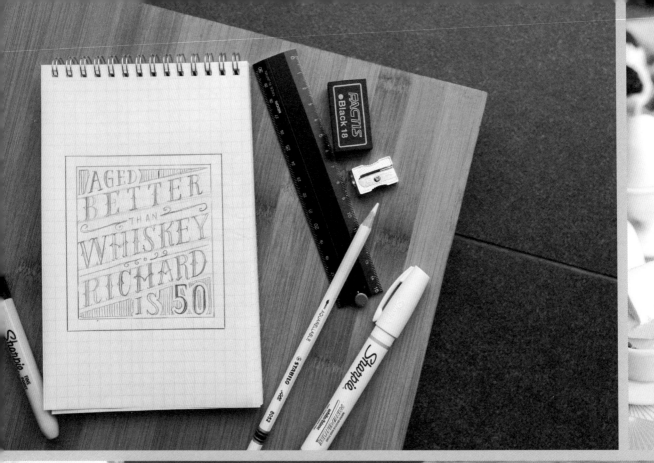

Lettering

ON WOOD

In the three wood projects ahead, we will be celebrating a fiftieth birthday with a men's Whiskey and Cigar Bar, lettering a cutting board as a hostess gift, and giving an old secretary desk a face-lift with a couple of coats of paint and lettering directly onto the desk to create a defined piece of furniture.

Remember, wood is the trickiest surface to work with because there are many different types—raw wood, varnished wood, painted wood, etc.—that act differently. Also, it is sometimes virtually impossible to erase any errors without sanding. So, take your time and be mindful when working on your wood projects similar to the ones ahead. Take the time to review your tools for wood (page 25), and I always suggest to test your medium on the back of the surface if possible to see what works and what doesn't!

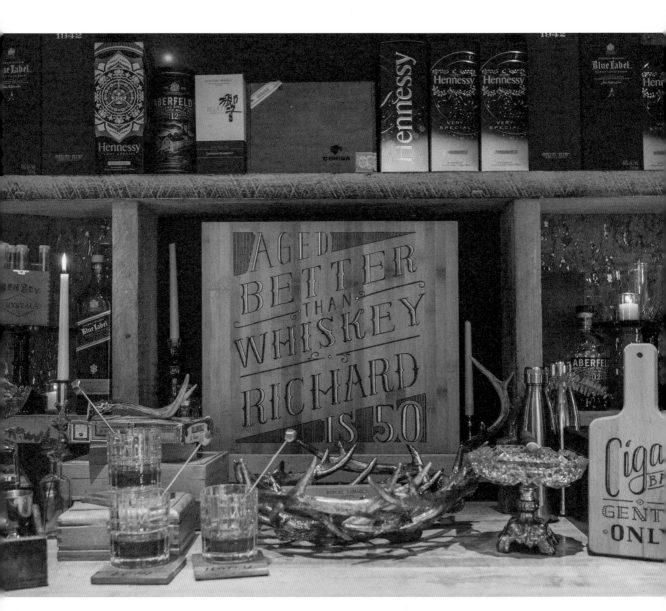

Event

WHISKEY & CIGAR BAR BIRTHDAY

The reason why lettering is so magical is because it can transform items and spaces into key pieces whenever you style a party. I absolutely love creating different types of signage to show that the typefaces you choose, along with the right surface, can create some serious style elements for party décor. A large signage piece that makes a bold statement will create a focal point for an amazing bar set up in this masculine Whiskey and Cigar Bar celebration for a man's fiftieth birthday. It can also become a keepsake and art piece for his "man cave" or home office after the event.

Tools & Materials

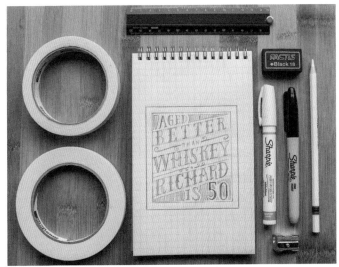

Cutting board (this one is from Ikea)
Masking tape
Stabilo All pencil, white
Damp paper towel
Sharpie permanent marker extra fine
 point, black
Ruler
Microfiber cloth
Sharpie water-based paint marker, white
Eraser

Steps & Tips

1. Have your pencil sketch handy. We will start by mapping out your lettering layout directly onto the cutting board with masking tape; remember to leave a border for breathing room. I decided to letter on the *back* of this Ikea board as there was a grooved border on the other side. That border could have potentially been pretty, but because this project was so detailed in the lettering, I didn't feel like it needed any more fuss or design to it. This board has a lovely smooth surface texture, made of bamboo material. Lettering on a surface like this is much easier than typical plywood, which sometimes has dips and grooves as normal wood does!

2. Use the Stabilo All white pencil to sketch your design onto the wood. Since bamboo is less porous and has a smooth surface, it is easy to correct or erase your sketch marks by using a damp cloth or paper towel. When your sketch is complete, dust off any remaining residue or debris from the white pencil.

3. Start executing the design with your Sharpie permanent marker in black. I love to freehand my lettering most of the time—I think the imperfections are actually charming. I never strive for perfection, but I do strive for uniformity. All letters should look like siblings in the same family, but not necessarily twins. However, use a ruler for parts where lines are more dominant. For this sign, all the edges on the left with the decorative side peak detail were drawn freehand, while lines without the peak details were drawn with the help of a ruler. Draw the structure of the letter form first, and then add the details after the base form is completed.

4. Add a shadow on the left side of the spotlight words "Better," "Whiskey," and "Richard." After you have lettered your piece with the Sharpie, remove the masking tape.

5. Add any detailing you'd like to your lettering. Clean up some of the remaining sketch marks by gently rubbing with a dry microfiber cloth to remove what you can. Remember: water may smudge the black Sharpie, so avoid adding water.

6. Use the Sharpie water-based paint marker in white to add highlights to your lettering. Remember to add the highlights on the *same* sides of each letter to create a visual balance. If you are not comfortable drawing them in directly, you can first sketch the highlights with the Stabilo pencil before applying the Sharpie.

7. Your sign should be complete at this point. Remove the tape around the borders and give yourself a pat on the back.

Note

The Sharpie permanent marker is not actually permanent on bamboo! It smudges quite a bit if you wet or try to erase it. As I say before every project, know what mediums work for your surface and how to cleanly erase mistakes. Again, I usually use the back of the surface to test applying and removing my medium before I begin.

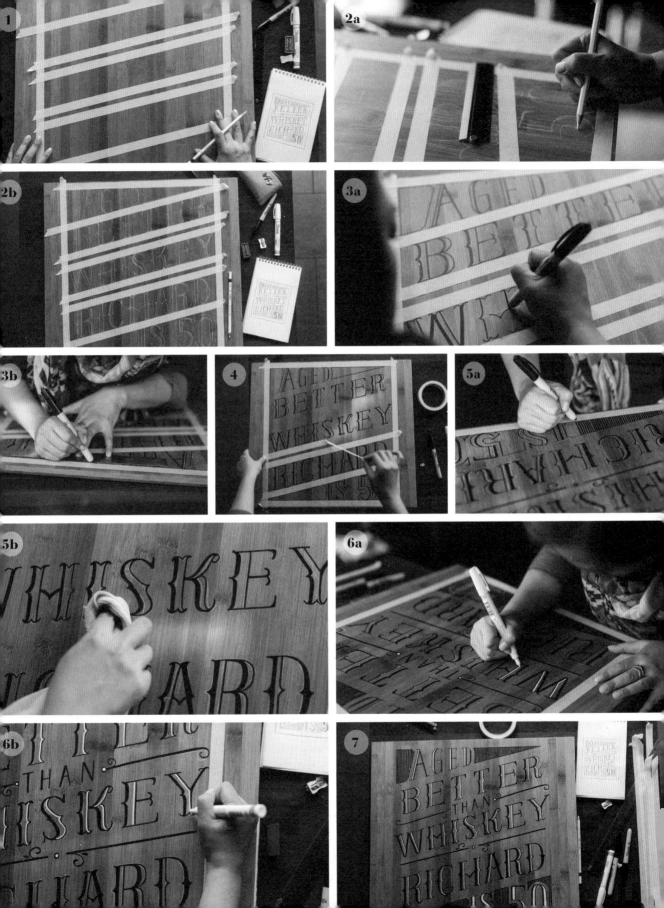

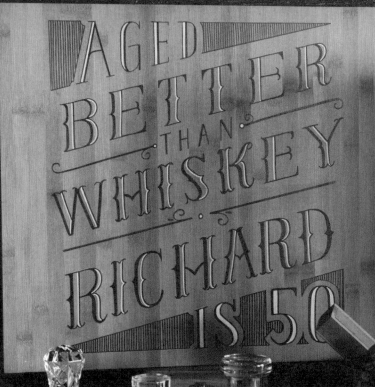

AGED
BETTER
. THAN .
WHISKEY
. RICHARD
IS 50

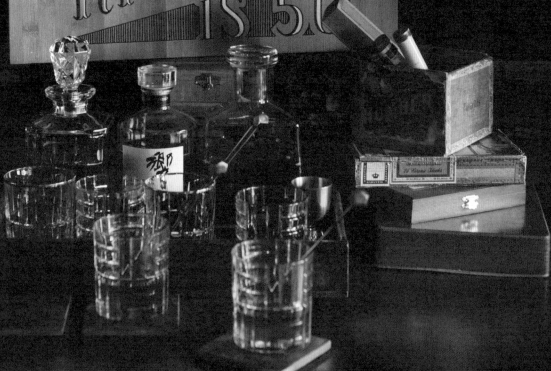

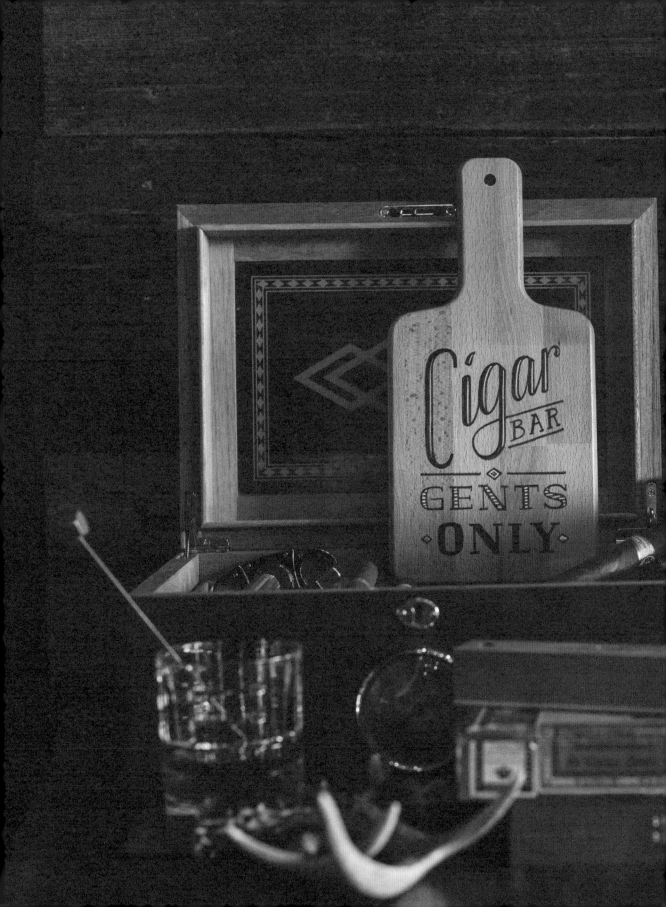

SIDE PROJECT IDEAS

◆ ◆ ◆

Celebrations and events always provide a multitude of ideas for lettering. For this Whiskey & Cigar Bar celebration, I also created other pieces to further style and decorate the event. I made a sign to showcase the cigars, also made from a cutting board from Ikea, and personalized coasters as take-home gifts. I also crafted food signage and labels on black slate. The combination of wood and slate surfaces was a great touch to the styling.

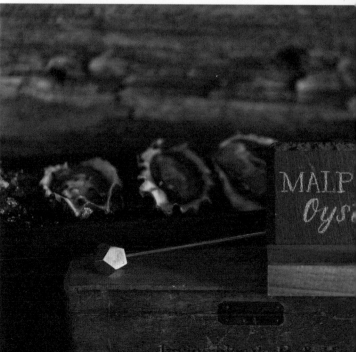

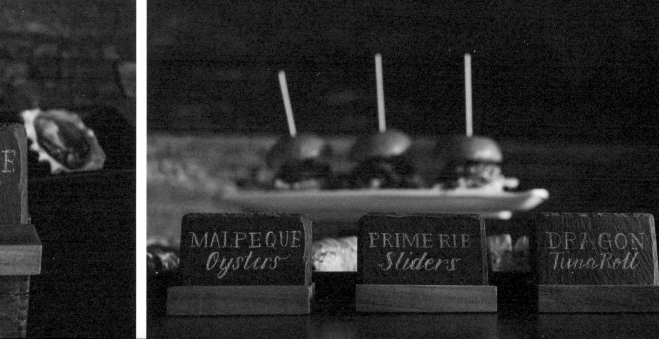

MALPEQUE
Oysters

PRIME RIB
Sliders

DRAGON
Tuna Roll

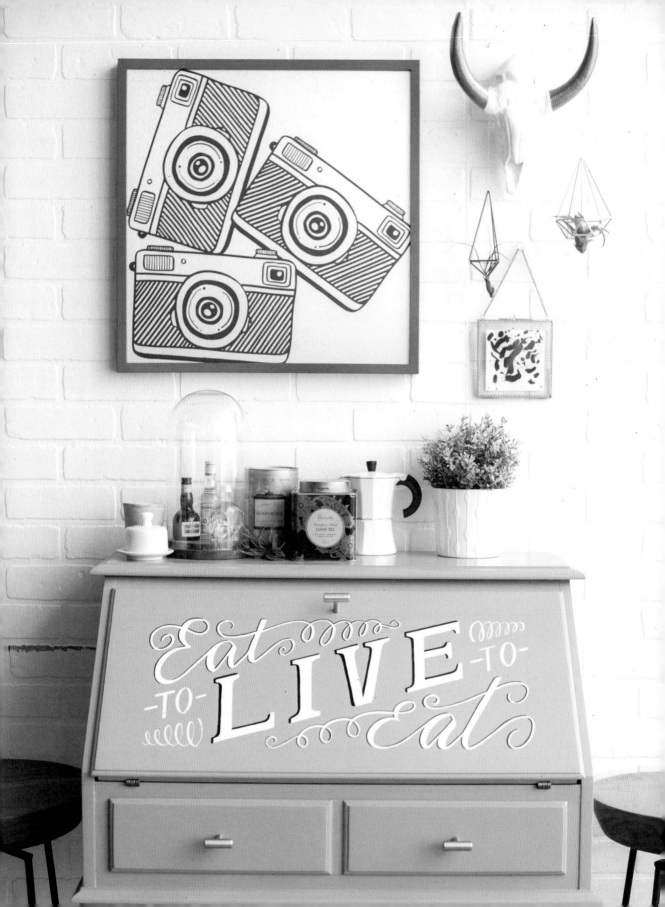

SECRETARY DESK CONVERSION TO COZY DINING SPOT

I am fascinated with antiques—the shape and details of old furniture are so much more ornate then modern pieces these days. And so, to my husband's frustration, piece after piece regularly shows up in our home, and more than once I have brought home secretary desks. Secretary desks, especially ones with a panel that can open up into a working surface and close back up again, are really intriguing to me. I'm just obsessed with their wondrous assortment of compartments, storage shelves, and organization layouts. What I like most about them is the ability to hide your mess by folding the table up and out of the way. This function alone creates an endless idea of what this piece of furniture could be. A minibar, a vanity for makeup, or a small eating area! Choose the right paint color and adorn it with beautiful lettering to dictate how you want that piece of furniture to be used. For this project, I have transformed my secretary desk into an eat-in nook for a bachelor pad or a loft space, where space is limited. This amazing piece is foldable and can open up for meal times; it can also conceal and store condiments, napkins, and dishes when not being used. And I figured that the phrase "Eat to live, live to eat" was an appropriate quote!

This desk was sanded and painted by yours truly. I love the color gray—it's neutral, and it fits any type of décor, whether in a quiet or bold fashion, depending on your project. I used furniture paint, which is of the latex variety, to withstand wear and tear. Since normal paint markers don't stick to this type of paint as easily, take note of the special tools for this particular project.

Tools & Materials

Painted secretary desk
Masking tape
Stabilo All pencil, white
Acrylic paint, white
Paint tray
Small container of water
Paintbrush
Sharpie oil-based paint marker, black
Paper towel

Steps & Tips

1. With your pencil sketch in hand, map out the sketch with masking tape. Because there are some bold capital letters in this project, create a border and tape up those sections to ensure good spacing between letters. Since the word "Live" is the star of the show, we want to make sure it is centered and balanced.

2. Sketch your letterforms with the Stabilo All. Since this pencil is water-soluble, we can easily rub it off with a damp paper towel after the permanent medium is applied.

3. For this project, use acrylic paint, which starts as a liquid, but dries into a plastic. This medium will withstand the everyday use of this eat-in table. Prepare the paint on a tray and have fresh water handy. I like to use repurposed styrofoam trays from my groceries as my paint palette, because cleaning up is easy and I can simply toss it away after the project. If you already have your own palette, wrap it with cling wrap to provide a layer for the paint—all you have to do when cleaning up is remove the cling wrap and toss. I have a variety of brushes—brushes for tight corners and fine lines, a brush with a flat head to create straight lines, and fuller brushes that can fill in large areas of the design.

4. Start painting! Acrylics are great, but they do require a couple of coats to get an even, streak-free look. Remember to let one coat dry before applying the second and third layers. Take note of how the tape above and below the word "Live" keeps the height of the word neatly in line. Oh, how I love tape!

5. After the white lettering, remove the tape. Now, use the black Sharpie oil-based marker to create shadows. This is a very controlled and tight step, so a paint marker works well. Once oil paint dries, it is very durable. Sometimes, oil and latex don't stick well together, but in this case the lines were fine enough for it to work out well. You can also consider using black acrylic paint, though it is not as quick, convenient, or controlled as a paint marker.

6. I used the shadows for the spotlight words "Eat" and "Live," leaving the other words less bold to allow the main stars to shine. Remove your masking tape border, and there you have it! An eat-in area that tidies up in a snap!

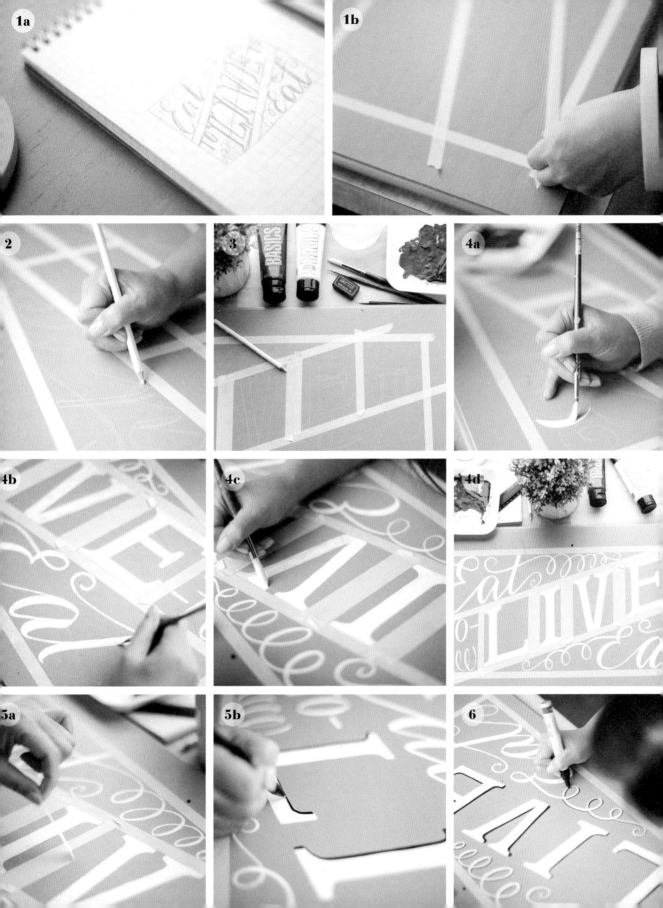

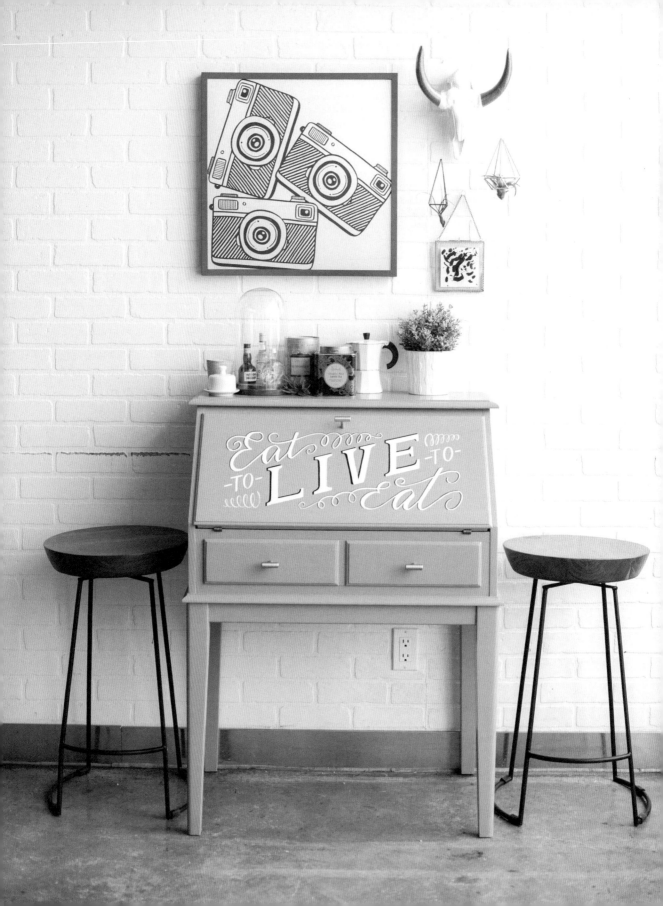

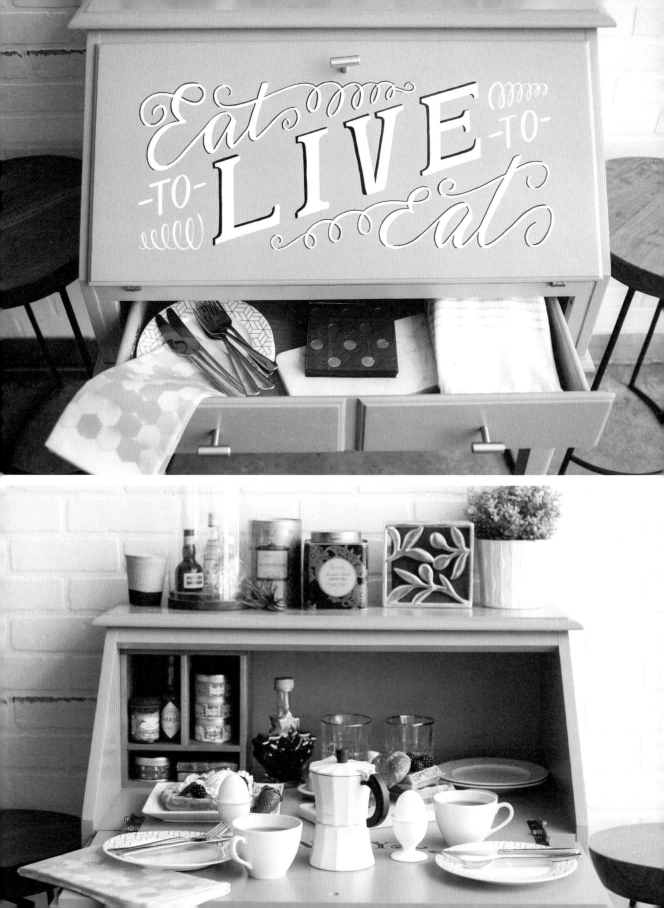

SIDE PROJECT IDEAS

◆ ◆ ◆

I lettered the word "Enjoy" on the desk and added some gold foil detail around each letter by applying a layer of two-way glue. Two-way glue bonds permanently if you stick something to it when wet; when it is dry it has a less sticky bond, similar to a sticker. I use Zig 2-Way Glue Squeeze and Roll pen. The great thing about this pen rollerball format is the control it gives you during application. I use this glue pen to create gold foil prints and details all the time. Apply the glue within the letters, and let it dry, about an hour is best. Then, press the gold foil on top, and voila! Fancy!

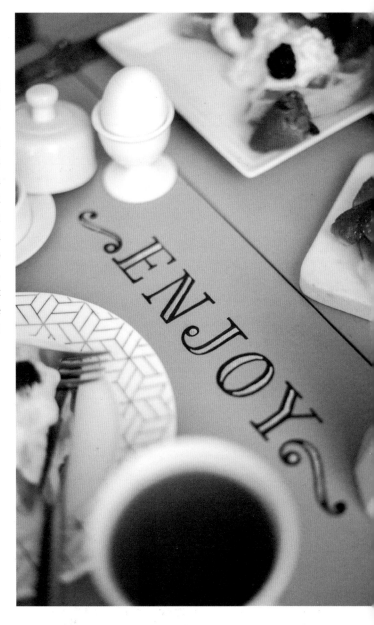

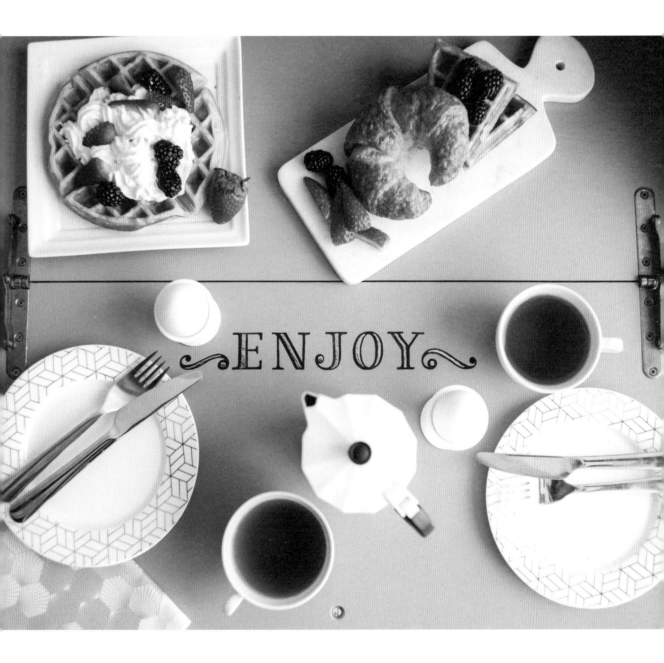

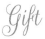
Gift

HOSTESS GIFT BASKET

Gift baskets are always an easy way to give something personal and useful at the same time. Depending on the occasion, I choose items based on color or theme to build the perfect basket of goodies that will be well used as well as beautiful. Casual gatherings and get-togethers happen all the time among family and friends, and a hostess gift basket is perfect for friends who love hosting parties, whether it's a barbecue or ladies brunch. I used a beautiful wood and marble cutting board as a blank canvas for my lettering. They can choose to hang it in their kitchen as artwork, or wash off the lettering and use the board.

I decided to use a circular board for this project because circular signage is not commonly used. Experimenting with different layouts and shapes stretches your creativity, and luckily cutting boards come in a wide variety of shapes and sizes; they also make great blank canvases that are already beautiful even before they are lettered on! To get ideas for lettering, think about food quotes you love, or family recipes. You can create a whole gallery wall with quotes about eating, food, and family—all lettered on cutting boards.

Tools & Materials

Cutting board
Stabilo All pencil, white
Masking tape
Sharpie water-based paint marker, white
Eraser
Damp paper towel

Steps & Tips

1. Have your pencil sketch on graph paper ready. Next, map out your borders. Usually, I delineate borders with tape, but since we are working with a circular shape, that would be very tedious. I freehand my circles most times, but if you want to create perfect circles, please use a compass. You can also use handy objects around the home and office—think plates, masking tape, cups, or lids from kitchen pots (the latter is actually my favorite because you can hold firmly onto the handle in the center of the lid while you trace the circle).

2. Start creating your circular guidelines directly on the board with your Stabilo All white pencil. Make sure the word "People" has a height guideline and the phrase "Best People" has a line to sit on, so you can balance the lettering. Treat the outside circle like the border of the artwork. Mark out the area directly in the center with masking tape where you will draw the fork,

heart, and knife. This way, you can sketch and work on the words above and below this section while having a good sense of spacing for the piece.

3. Use the masking tape to make sure your sentences are on a straight line and not leaning to one side; we want all the lettering to be parallel to each other. This creates repetitiveness, and the eyes love that. Sketch everything out with the Stabilo All, then remove the tape to reveal your design sketch.

4. Take your water-based Sharpie paint marker and go over the sketched lettering. Since the sketches are a guide, sometimes I make adjustments as I go while I lay down the more permanent medium.

5. Use the eraser and damp paper towel to remove the remaining Stabilo sketch marks. Your personal piece is complete, and a great addition to your gift basket!

1a

1b

2a

2b

3a

3b

3c

4a

4b

5

SIDE PROJECT IDEAS

◆ ◆ ◆

Think about the possibility of lettering family names on these boards, such as "For the Gray Family." Instead of writing a card, you can also letter on one of the items in the basket. Place all your goodies, be it fancy oils and spices or alcohol and glasses, and watch your host/hostess receive it with joy!

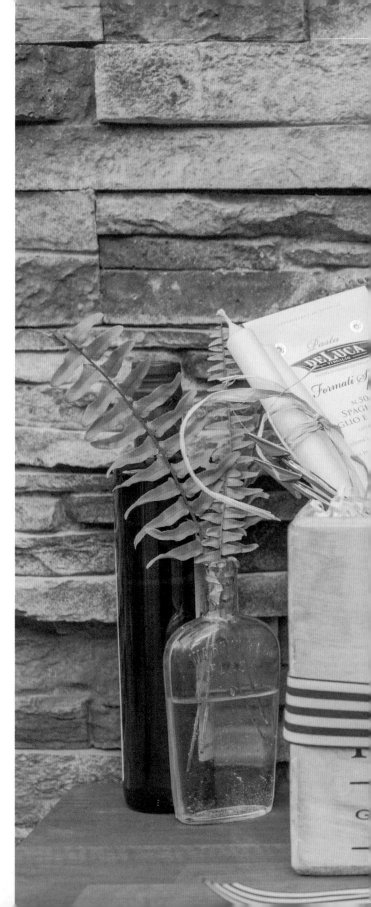

PEOPLE WHO *Love to Eat* ARE ALWAYS THE

Renton

ESTABLISHED

S. B___ING SUP___OLS

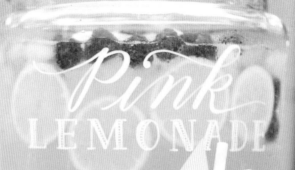

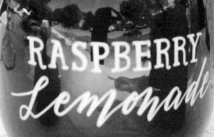

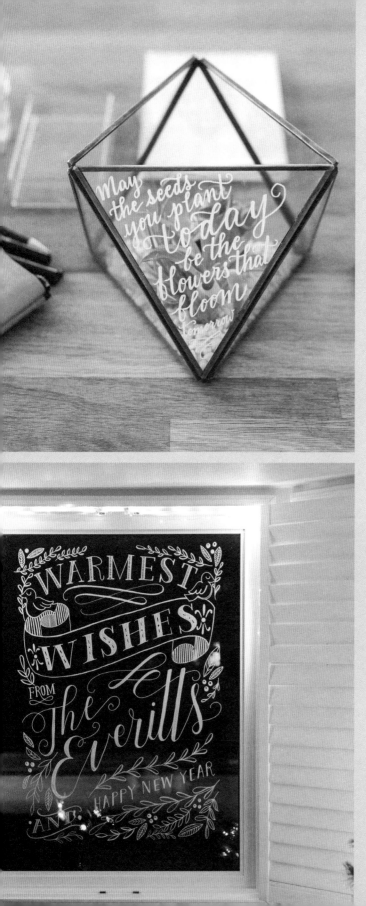

Lettering

ON GLASS

In the three glass projects ahead, we will be celebrating a fifth birthday with a Pink Lemonade Party, creating an air plant terrarium as a gift with words of wisdom, and starting a family holiday tradition of lettering a Christmas window for decoration, in addition to stringing lights and hanging the wreath on the door.

Because glass is transparent, there are many beautiful effects and ways to letter on glass. Know your mediums and tools well, so you can tackle the job easily. In cases where you need to letter directly onto odd shapes and curved surfaces, sketch directly onto the item and then execute with another medium. However, in the case you are lettering on a flat panel of glass, you can first create your sketch on a piece of paper sized to the glass before execution. You will see both these methods in the projects ahead.

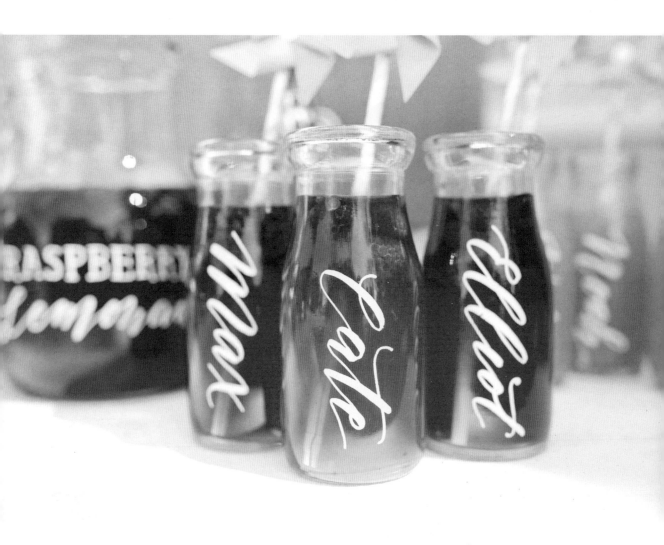

PINK LEMONADE PARTY

I am a mom of a lovely little girl. She makes me feel young and old at the same time; how magical is that? Children will always be a reason to celebrate, and birthdays are one of the best reasons to do so! This project was inspired from a party tradition my parents did when they celebrated ours: personalized glasses and cups for each guest. During my childhood parties, it was actually styrofoam cups and a ballpoint pen, and it was done out of necessity as my parents did not want nameless half-full cups of soda pop strewn around the party. On top of its functional use, we will take this idea up a notch by making it beautiful, perfect for styling and photographs.

For our Pink Lemonade Party, we chose vintage glass milk bottles as our vessel. There are many other options for glassware for each future party you throw, and you can reuse this idea again and again. Even plastic acrylic cups are a good option for younger kids if breakage is a concern. Lettering on glassware is also great for adult parties—it adds a personal touch and eliminates the need for wine charms and items of the sort. Note: we want the lettering to be temporary for this project, so we will be using the appropriate tools.

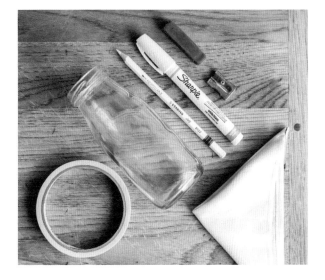

Tools & Materials

Masking tape
Stabilo All pencil, white
Tissue
Sharpie water-based paint marker, white

Steps & Tips

1. Using your graph paper, compose a list of the names you will be lettering. There is not much composition and design involved in lettering single words, so I suggest practicing sketching out how that name should look. Keep in mind that you only have a certain width available to letter, so if the name is a longer name, the letters will have to be drawn smaller to fit the glass.

2. Once you have your names sketched out, map the glassware. I use masking tape to mark out the space and height needed for my lettering; this will also ensure that the lettered glasses will look cohesive as a set. When the type looks similar in height and weight, and when they are placed together, they will make a bold visual statement and create a beautiful display.

3. With the taped glasses ready to go, take your white Stabilo All pencil and sketch the names directly onto the glass. This medium is easily removable with a tissue and is meant to be a guide for the execution—laying down temporary lettering.

4. Use your white Sharpie water-based paint marker for the execution. I feel the color white shows up the best on glass and mirror, and has the best contrast. You can use other colors (Sharpie offers other water-based colored paint markers), but I like to keep my lettering classic and clean. I usually suggest white, black, and, at most, gold. But take your party into consideration! Since this is a pink lemonade party, lettering in pink and yellow ties in nicely with the theme.

5. Once you have lettered the names, remove the tape and clean up the Stabilo sketches with a tissue. There you have it—custom glasses for your little guests.

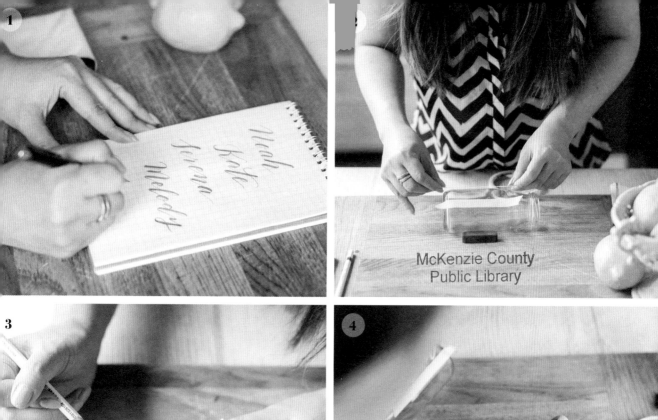

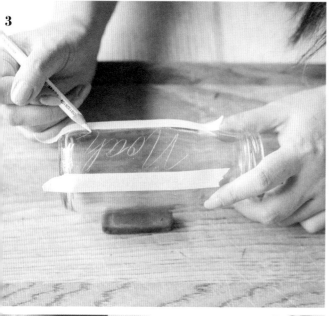

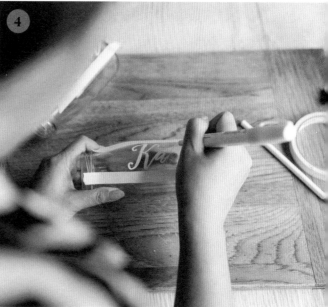

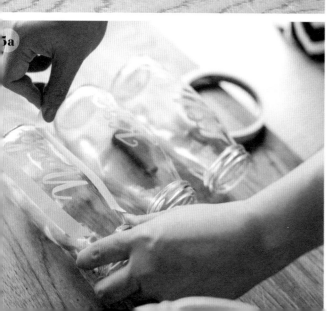

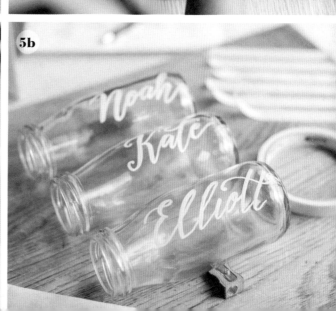

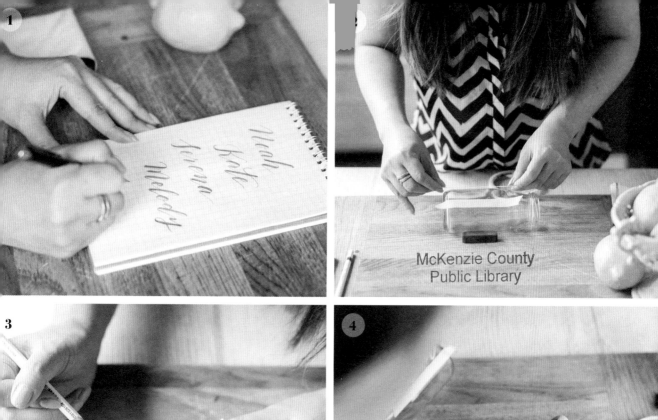

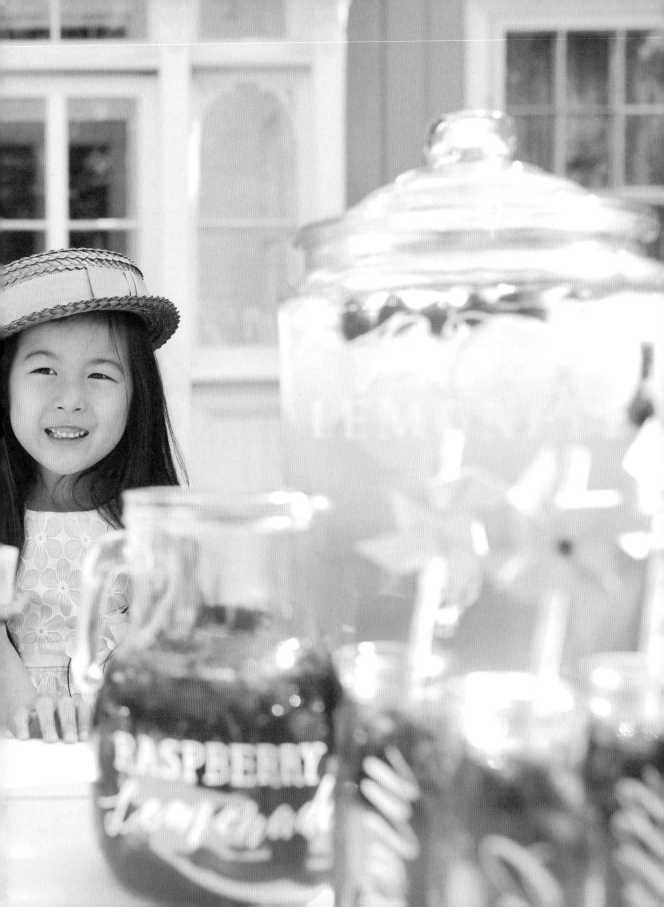

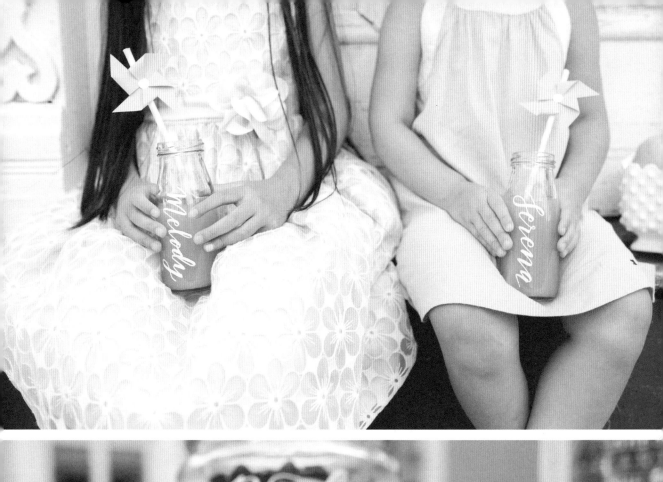

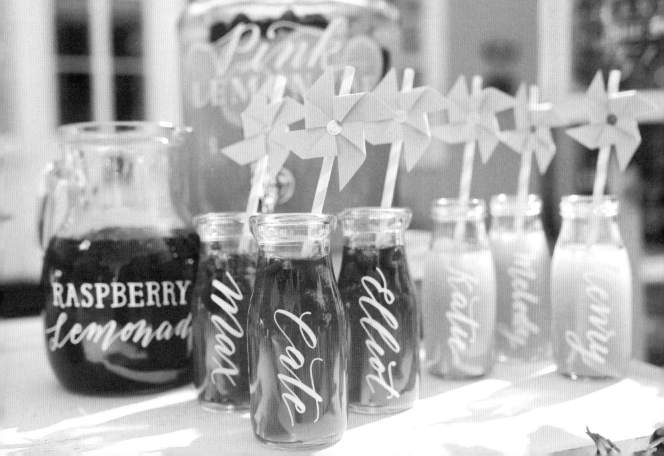

SIDE PROJECT IDEAS

◆ ◆ ◆

I created many other hand lettered glass projects for this Pink Lemonade Party, such as signage for directions, the welcome sign, as well as a little personalized piece about turning five years old. Welcome signage is an especially good idea since guests are introduced to the tone, style, and theme of the party immediately when they see the piece. I also created smaller pieces, with the words "She's sweet, she's tart, she's 5!" and used them as photo shoot props for the day. I always suggest taking photos of the décor and the birthday child before the other kids arrive, when everything is still full, neat, and organized. Good luck trying to get them to stay still once everyone is present! Whether you're lettering for an elaborate event or a casual backyard BBQ, keep vintage windows around so you can whip up a sign or menu at any time with your water-based marker.

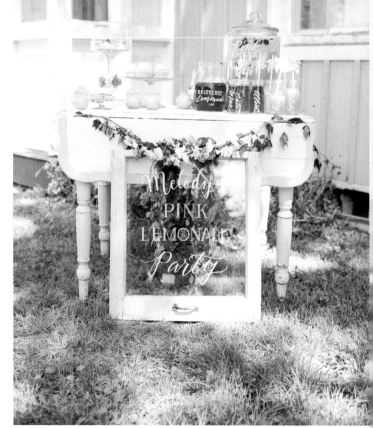

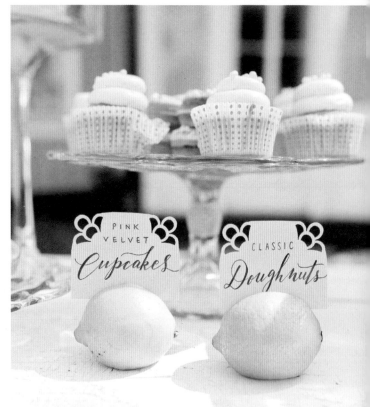

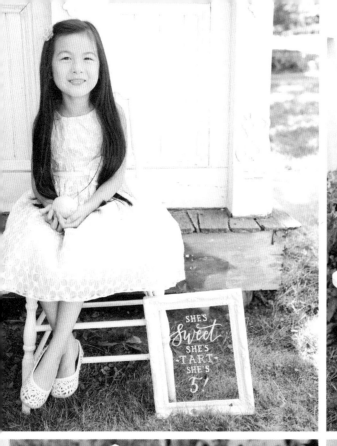

She's
sweet
She's
·TART·
She's
5!

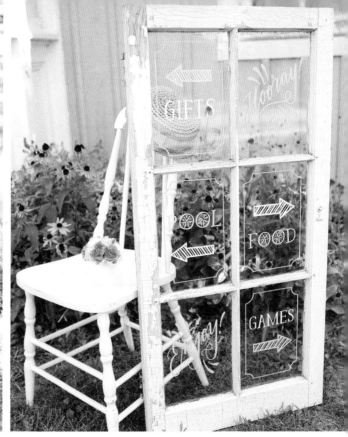

GIFTS

Hooray

POOL

FOOD

Enjoy!

GAMES

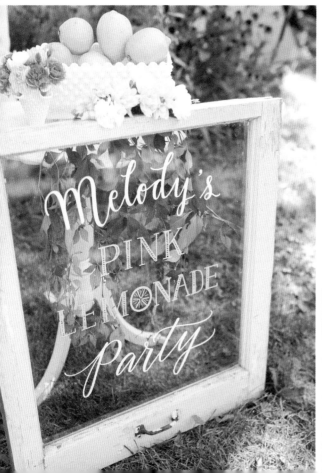

Melody's
PINK
LEMONADE
Party

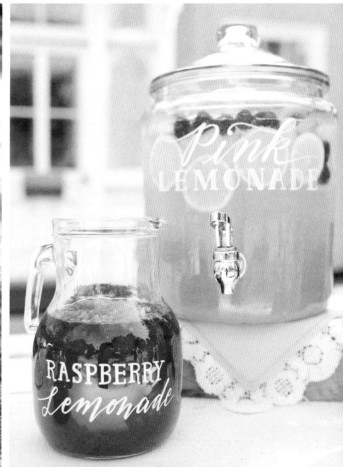

Pink
LEMONADE

RASPBERRY
Lemonade

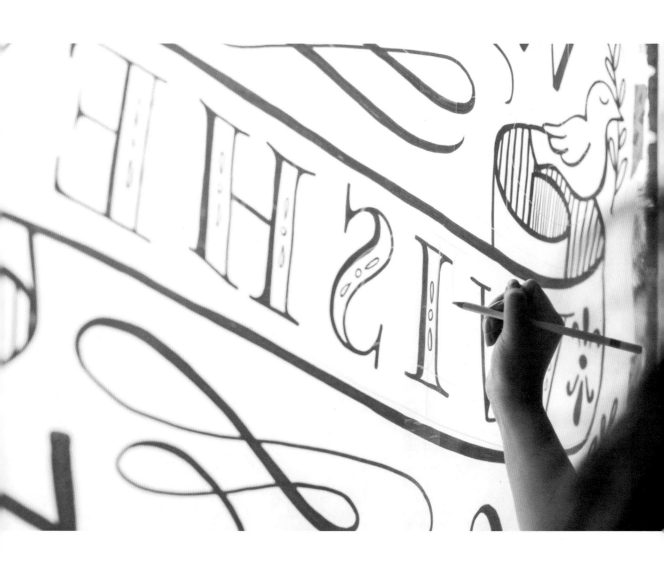

Home Décor

HOLIDAY WINDOW

There is a particular coziness about the holidays. It could be the anticipation of having time off, the family gatherings, the festive parties, the abundance of baked goods I think it also has something to do with the atmosphere. From restaurants to the mall, everywhere is decked with "boughs of holly" or something of the sort to let you know that Christmas is coming!

We also have our own traditions in the home that create that feeling. We put up Christmas lights; decorate the tree with ornaments, tinsel, and lights; hang the wreath on the front door; and put up stockings on the mantle over the fireplace.

For this project, I'll show you how to make a holiday window for your home. Why should stores and shops get all the fun? If you think about it, the lights, wreath, reindeer, and snowmen outside already bring joy to the neighborhood, so a holiday window, big or small, also sends "Seasons Greetings" from your family to the entire community. If you don't have a prominent window at the front of your house, consider using the glass on the storm door. Since there will be many guests coming and going over the holiday season, a hand lettered greeting at the entrance is always a lovely surprise and conversation starter!

Tools & Materials

Measuring tape
Tracing paper roll
Regular Sharpie, black
Painter's tape
Stabilo All pencil, white
Sharpie water-based paint marker, medium
 point, white
Gesso primer for surface preparation
Paintbrushes
Clear packing tape

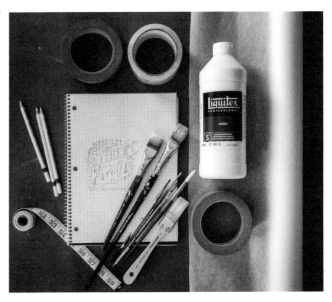

Steps & Tips

1. Measure your window. Remember: you should always have a healthy border around your artwork so you don't letter too close to the edge of your window. I would suggest leaving a 5-inch-long border on all four sides to ensure proper spacing and composition. After this measurement, you'll have a good idea of the shape of your space for sketching.

2. Create a small detailed sketch of your design on graph paper. Focus on what you really want to showcase in terms of spotlight words, as well as any decorations you may want to add.

3. From there, cut a piece or pieces of tracing paper to the size of your window design, and copy your design onto the tracing paper. Use a regular sharpie to color in your design so that it shows up well on the tracing paper. We will be using this as a guide when we are executing on our window, which is why it must be translucent.

4. We will be attaching the tracing paper on the outside of the window and sketching the design on the *inside* pane of the window. First, hold up the tracing paper to the inside pane of the window to figure out where you want to place it. Mark placement reference points on the inside.

5. Next, go outside and attach the tracing paper on the *outside* pane of the window, with the design facing out. You will be executing the final design on the inside pane of the window—lettering on the outside is not favorable as your work will be exposed to the elements. Lettering on the inside ensures your artwork will be nice and dry throughout the holiday season!

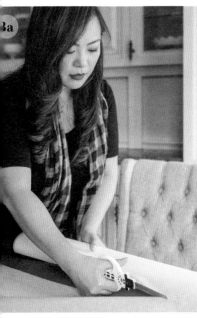

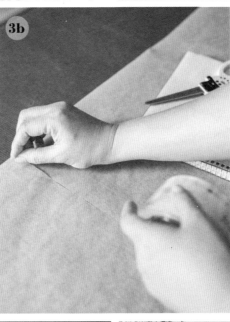

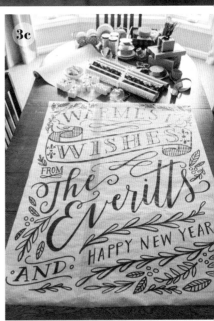

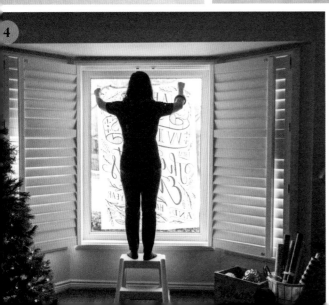

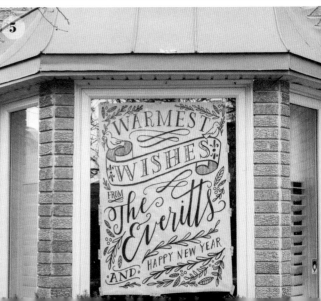

6. From the inside, follow the tracing paper design and trace your sketch onto the window with the Stabile All white pencil. Include the areas that are thickened as well. Since you are viewing everything in reverse, it's tricky on the eye and hard to make natural judgments during execution.

7. Once the sketching is complete, remove the tracing paper to see your Stabilo sketch clearly. From the inside, start lettering over your sketch with the Sharpie water-based white marker with the medium nib. This marker has a thicker nib and works well to produce a wider line when lettering on large spaces.

8. Once the line work is complete, take the gesso and brush to fill in all solid white areas. A thicker brush works much faster to color in the areas compared to a marker.

9. Erase any remaining sketch marks from your Stabilo on the outside. Your window is complete! Your neighbors will be thrilled by your holiday spirit, efforts, and sentiments. Beautiful in the day and magical at night!

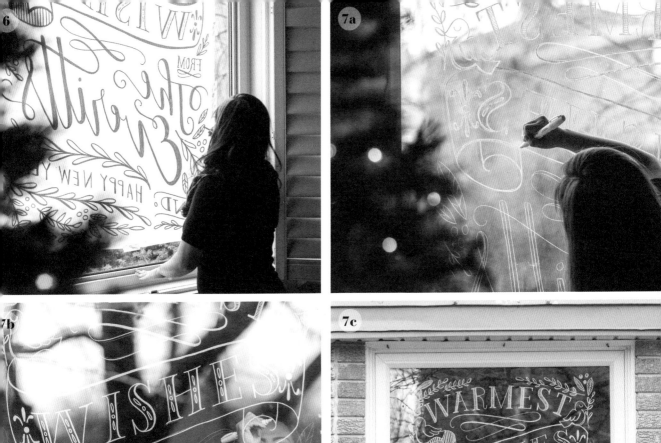

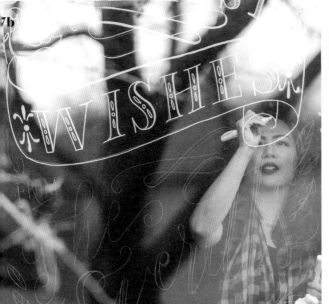

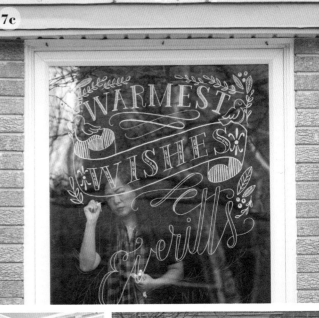

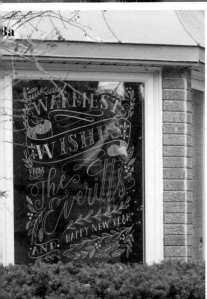

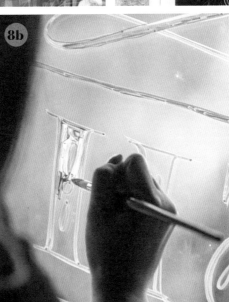

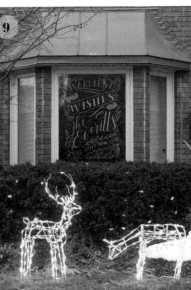

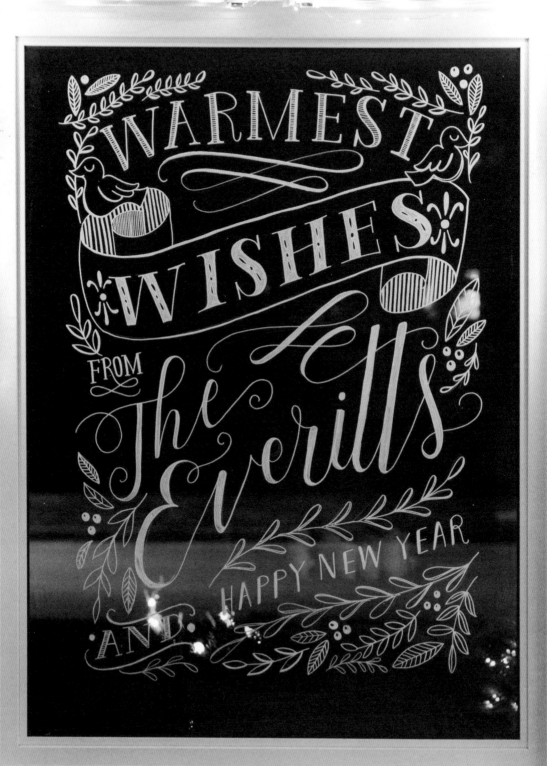

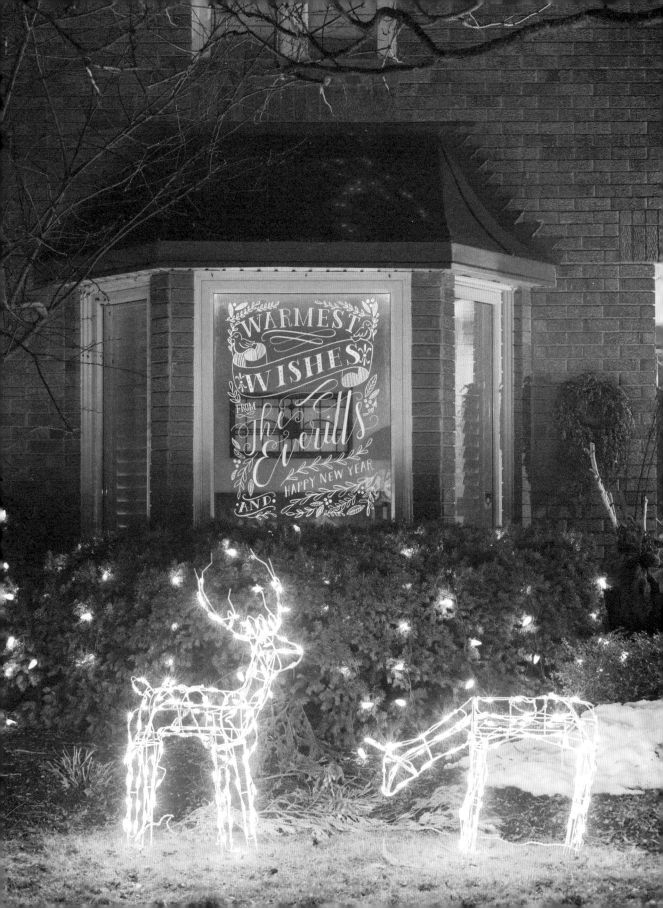

SIDE PROJECT IDEAS

◆ ◆ ◆

Consider having a hot chocolate party during the holidays. A hot chocolate bar would be popular among your guests, especially if you offer special holiday spirits, such as coffee and peppermint liquor, along with amaretto and Irish cream! Create festive signage for the bar by lettering directly on top of a regular photo or poster frame. Remove the backing of a frame and place evergreen leaves behind a lettered glass to create a natural decorative touch that is perfect for the season. You can also consider lettering on small appliances such as this Crock-Pot.

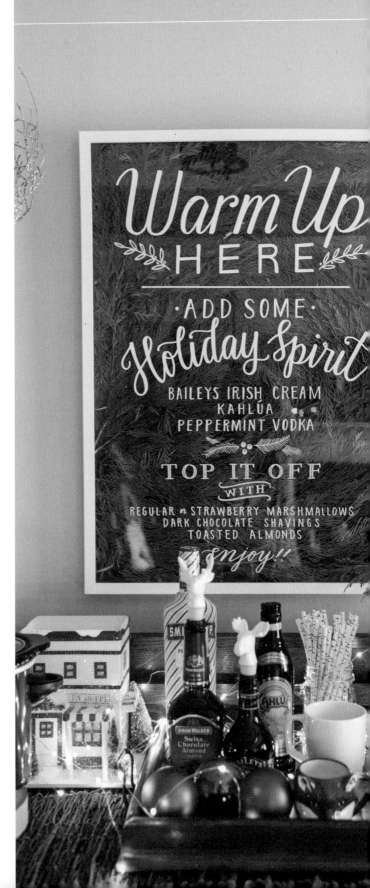

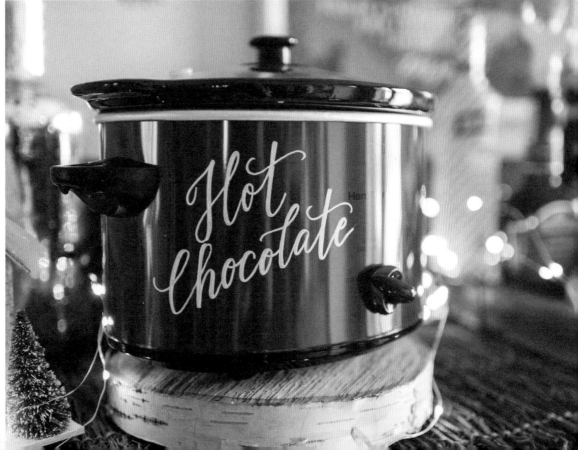

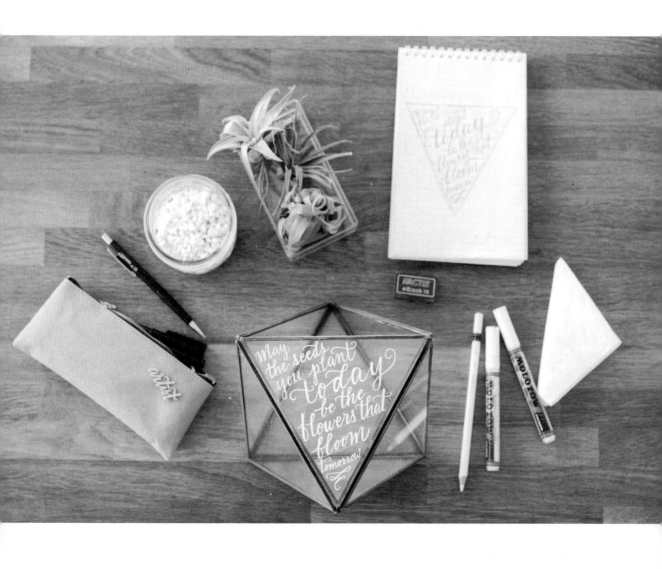

Gift

AIR PLANT TERRARIUM WITH QUOTE

Flowers and plants bring a lot of positivity to their surroundings. Plants provide oxygen, greenery, and life that just sets a calm tone. Plants and flowers provide many health benefits besides cleaning the air; they also create a relaxing atmosphere that can lead to creativity, productivity, and less stress!

Whenever I have to give a gift, my first go-to idea always involves a plant. I am not exactly a florist or a botanist, and I like to keep in mind that the person may want a low-maintenance plant. Air plants are my favorite, as they require minimal attention but provide the same wonderful effects. There are a wide variety of amazing air plants that thrive with no soil (so they are not messy, either!), which means I get to look for a pretty vessel to carry them in. Glass terrariums and other glass containers are perfect as they let light through—plus, I can letter a personal touch onto the glass. Bring zen to any desk with a low-maintenance plant and a positive quote!

For this tutorial, I chose a quote for a friend who had just started a new job: "May the seeds you plant today be the flowers that bloom tomorrow."

Choose different sayings or quotes according to your gift—whether to thank loved ones, heal broken hearts, encourage someone, or say a simple "thinking of you." Whoever receives this gift will never be disappointed. Using your natural handwriting, especially if you have lovely penmanship, makes the piece ever more unique. Always consider using your natural handwriting for small and customized gifts for those near and dear to you. Even if it's not perfect, it is personal, which makes it all the more special.

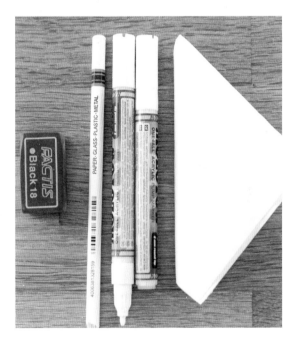

Tools & Materials

Masking tape
Stabilo All pencil, white
Molotow acrylic paint marker, extra fine tip, white
Tissue

Steps & Tips

1. Since this gift is personal, the lettering can be a bit less structured and more natural to your own writing. A sketch should still be made for preparation, so you have a guideline for reference.

2. Start with the Stabilo All white pencil and draw your lettering lines. Since the surface is quite small, I cannot use my usual masking tape to keep me in line, so I draw lines with this tool as it's easy to erase afterward.

3. Use the Stabilo All again to sketch the quote, making sure the words are balanced and fit into the space accordingly.

4. Use the Molotow paint marker to execute. Since there is a chance the terrarium may get wet, this medium is the right choice as it can withstand wetness. You can go right over your sketched words or correct yourself along the way. Most times when I sketch, I already see that my lines are not perfect. As a result, I find myself correcting my lettering during execution. If there is an error with the white Molotow, you can try to scratch it off or use a Q-tip with nail polish remover.

5. Once you have completed your quote, take your tissue or microfiber cloth and gently remove the sketch marks.

6. Once your lettered vessel is ready, fill it with your chosen air plants and decorative touches. The simplicity of the white stones nestle the plants nicely. There you have it, serenity in a pretty package. A memorable gift for a momentous or simple occasion.

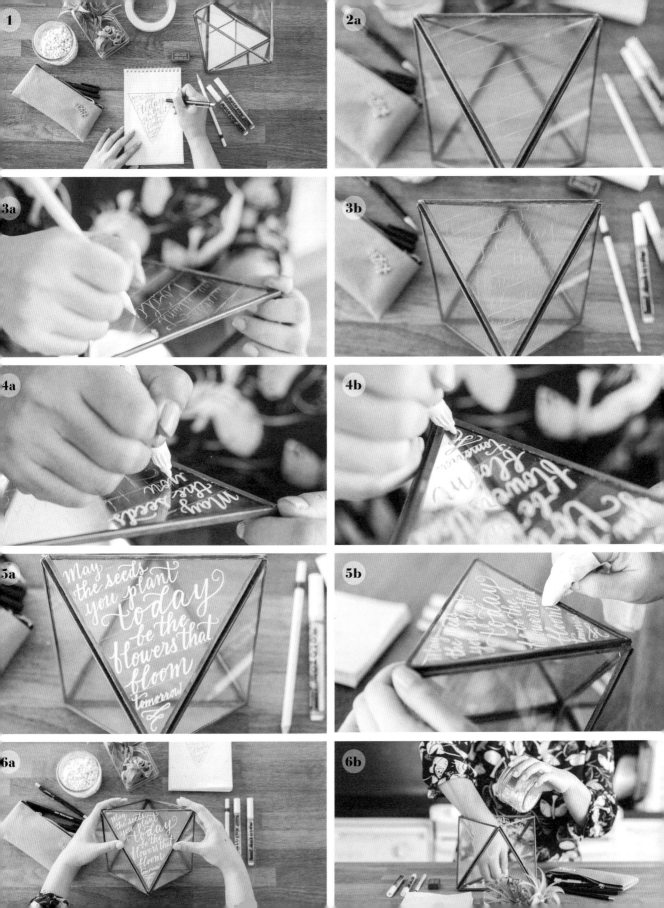

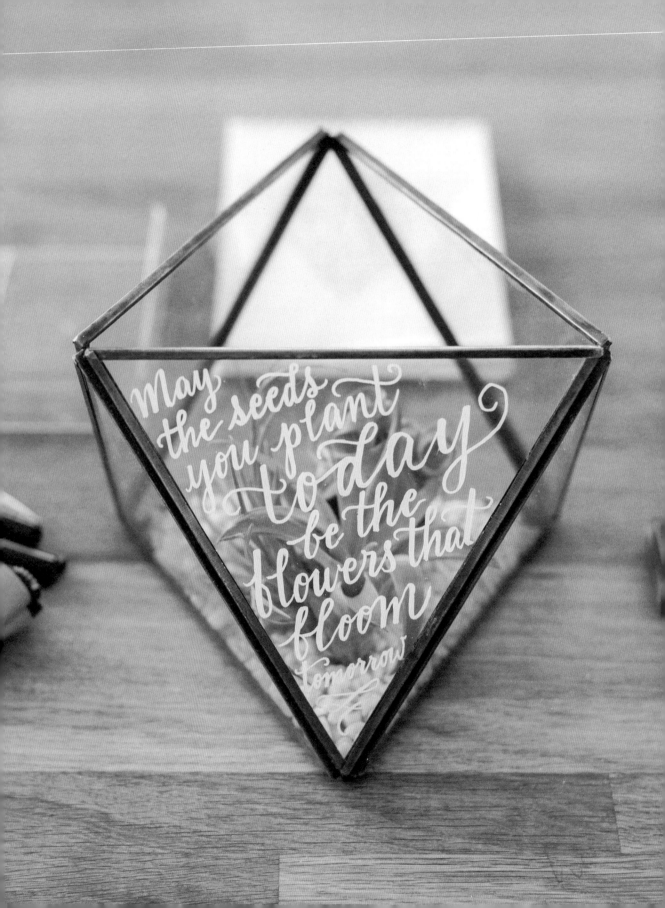

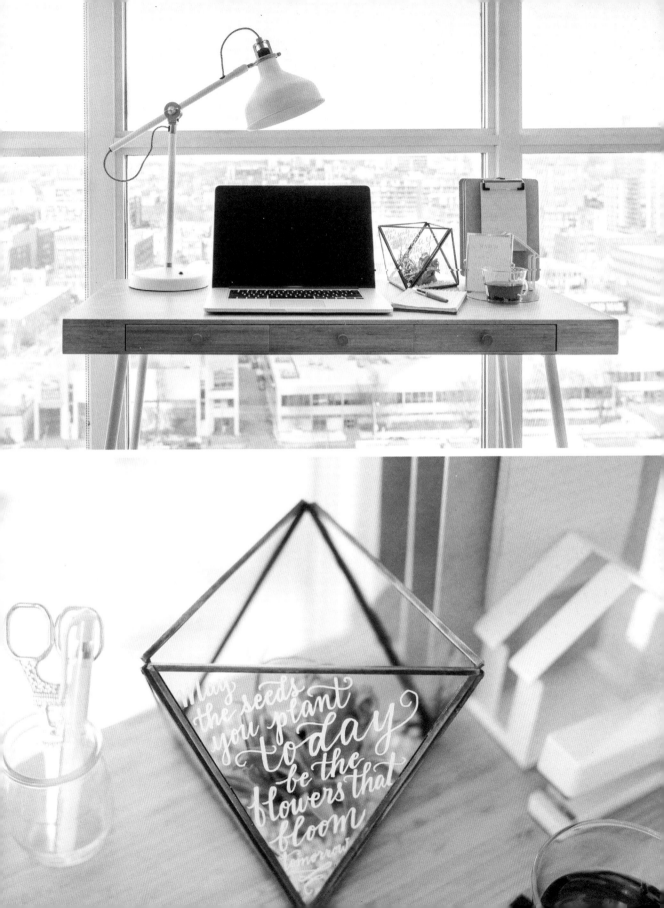

AMONGST
Friends & Florals
LET US
Celebrate
OUR
Kate

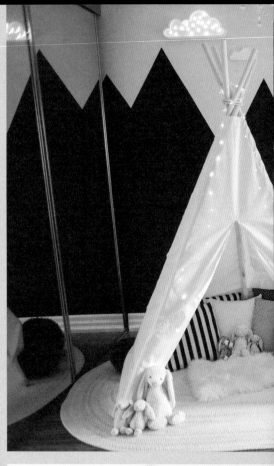

Kindly
REMOVE
YOUR
SHOES

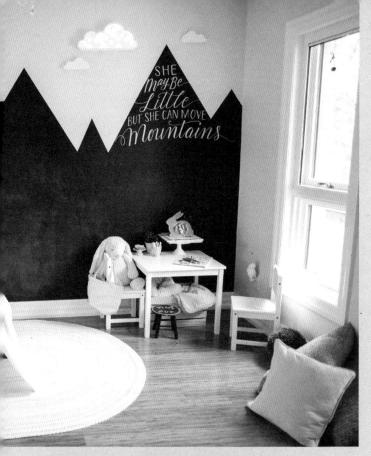

CHAPTER 8

Lettering
ON CHALKBOARD

In the three chalkboard projects ahead, we will be throwing a Bloom School Bridal Shower, crafting hand lettered signage for a nursery and baby gift, and creating a graphic playroom, bringing the outdoors inside with a chalkboard mountain mural and a lettered quote.

Chalkboard is such a distinct and versatile look. I associate it with many different aesthetics because it can be used to style every situation in different ways. Chalkboards can be a fun outlet for imaginative children, and it can also give a clean and modern look for a restaurant or bar menu. The key to styling chalkboards is the lettering you use, which will set the tone.

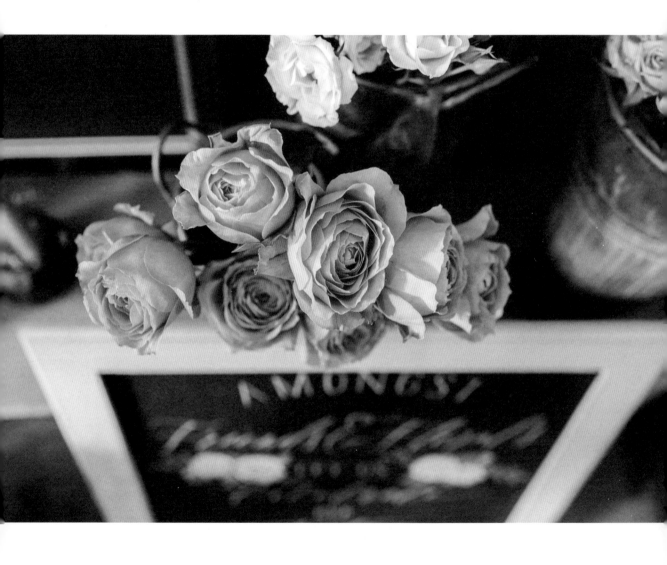

Event

BLOOM SCHOOL BRIDAL SHOWER

For this chalkboard project, I'm not actually using chalkboard at all! If my client wants a chalkboard look but doesn't necessarily need a real chalkboard, I often use black foam core. I call this technique, which I came up with myself, using a "mock chalkboard."

Black foam core is a surface you can easily find at local arts and craft stores, big box stores, and even in some dollar stores! The beauty of foam core is that you can cut it into any size you want with a utility knife. For example, I can fit a piece of black foam core board into a photo frame by cutting it according to size (remove the backing of the photo frame and use it to trace out the size on the black foam core). I often turn old, outdated, and empty frames into mock chalkboards. This method is quick, easy, and cost-effective. Visually, you will achieve similar results as if you had used a real chalkboard surface. The best part about mock chalkboards is that they are mess-free—they don't smudge, they are not dusty, and you don't have to worry about people rubbing their hands or clothes on them. The lettering stays put!

Note that while you can erase your artwork and restart on a real chalkboard surface, it is more tedious to do so on black foam core. If you need a do-over, I suggest you buy a new piece of black foam core and start again. Price-wise, it's worth it!

All the signage in this bridal shower was created on foam core. I found the frames on the side of a curb, and I sprayed them with rose gold copper spray paint. This project was so budget-friendly, and the best part is you can't tell that by looking at it!

Tools & Materials

Empty frames
Black foam core
Stabilo All pencil, white
Bohin France mechanical chalk pencil
Painter's tape, for delicate surfaces
Eraser
Measuring tape
Stabilo CarbOthello chalk-pastel pencils
Conté à Paris pastel pencils, portrait set

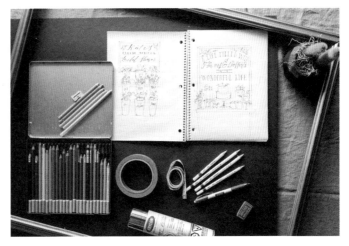

Steps & Tips

1. Cut your black foam core board to the size of your frame before you start working on it, so you don't have to bother with cutting it after the artwork is already executed. Your board should be sized and ready to go.

2. Map out your border with painter's tape, delineating the space for your spotlight script and where your basic fonts should be. I use delicate surface painter's tape (the surface of black foam core is essentially paper). Regular painters tape or masking tape may be too sticky for this surface and could rip off layers of paper. When applying the delicate surface painter's tape, I don't press very hard.

3. Sketch your design using the Bohin France mechanical chalk pencil. Again, because this surface is essentially paper, you can erase mistakes easily.

4. Once you have your chalk sketch in place, follow through with the Stabilo All white pencil. Note: although Stabilo All is a sketching tool and temporary medium on glass, wood, and mirror, it is *permanent* on foam core. Since this pencil is waxy, it sticks really well to the surface and does not smudge, unlike a real chalkboard! Perfect.

5. Since the theme for this bridal shower is "Bloom School," I had to add florals to the signage. For the floral designs, use the Stabilo CarbOthello chalk pastel pencil and the Conté à Paris pastel pencils. I almost never use real chalk unless I am filling in large surfaces; this way I keep my hands clean and my pencil points stay sharp. However, these mediums do leave a slightly dusty residue on your artwork, similar to chalk.

6. Remove your painter's tape carefully. Clean up your surface with a black eraser. Place it into your empty frame, and you are all set!

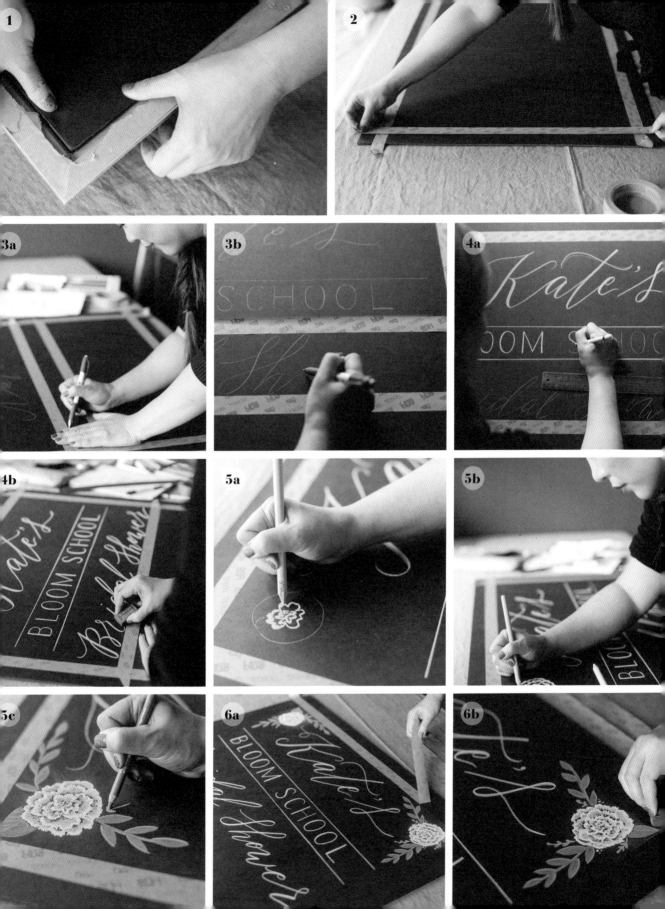

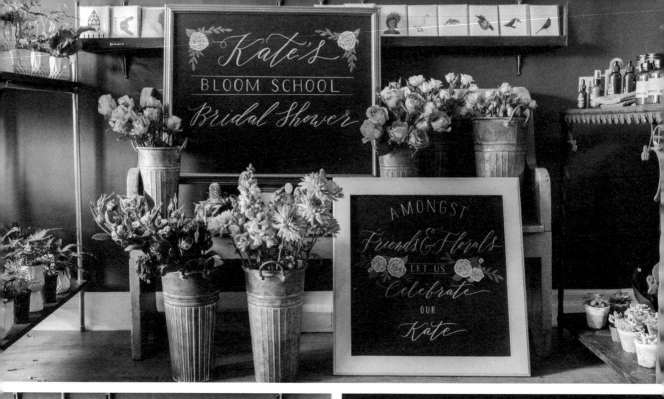

Kate's
BLOOM SCHOOL
Bridal Shower

AMONGST
Friends & Florals
LET US
Celebrate
OUR
Kate

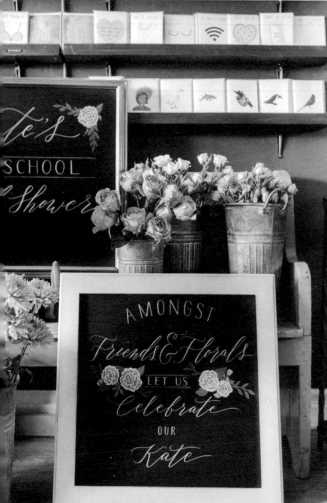

te's
SCHOOL
Shower

AMONGST
Friends & Florals
LET US
Celebrate
OUR
Kate

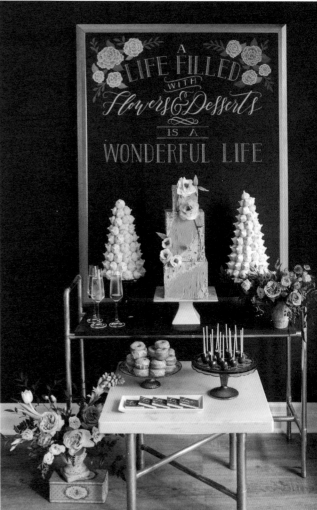

A
LIFE FILLED
WITH
Flowers & Desserts
IS A
WONDERFUL LIFE

AMONGST

Friends & Florals

LET US

Celebrate

OUR

Kate

SIDE PROJECT IDEAS

◆ ◆ ◆

During any event, I like to think about how signage can be functional decorations. In this case, lettered signage is used for a backdrop for the dessert table, as a welcome sign, and as simple placemats for each guest. For the latter, I cut the corners to create a more decorative look and also lettered each mat, essentially treating them like a large place card.

Place Mat Tutorial

It is really easy to create a template for these placemats that also serve as place cards.

Measure 1.5 inches from both sides of one corner and make a mark. Then take a cup or a side plate that is about 3 to 4 inches in diameter and line it up to both marks. Draw out a quarter circle, repeating for all four corners.

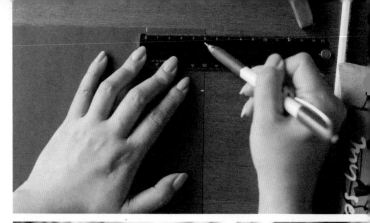

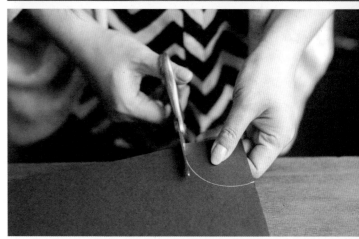

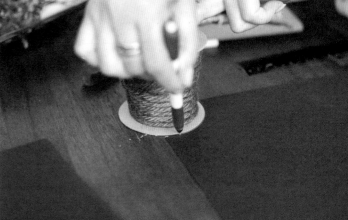

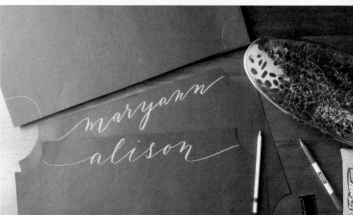

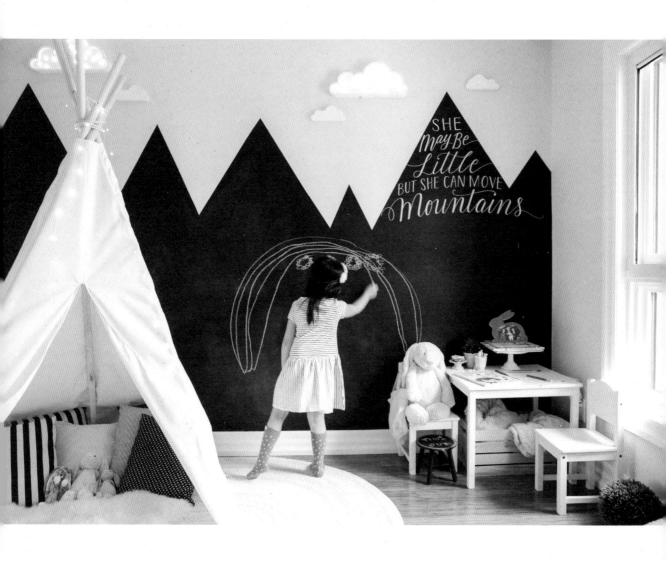

CHALKBOARD MOUNTAIN WALL PLAYROOM WITH QUOTE

Chalkboards are just so incredibly playful that it's no wonder children and adults are drawn to them. The ability to go wild with colors and shapes, all to have them washed away so you can start anew, seems too good to be true! In general, chalk paint can be really useful around the home. They allow you to turn your wall into a temporary writing surface, which is helpful for reminders, keeping organized during the week, jotting down recipes and phone numbers, or playing Pictionary! Other ideas include using chalk on cabinet doors, closet doors, or even the surface of a family dining room table. Think of all the fun that can take place at dinner—and that can be later wiped clean with a wet cloth.

For this project, I wanted to create a chalkboard wall for a little girl's playroom, accompanied by some inspirational words. We came up with an idea to create chalkboard mountain silhouettes instead of a full chalkboard wall, which would contain the quote "She May Be Little, But She Can Move Mountains." Instead of designing a super girly and feminine play area, we wanted to bring in an outdoor adventure theme, and this backdrop tied everything together nicely.

Tools & Materials

Drop cloth or newspapers
Painter's tape
Scissors
Masking tape
Chalkboard paint
Paint rollers
Foam brush, for painting the edges
Paint tray
Stabilo All pencil, white
Sharpie oil-based paint marker, white
Paper towel

Steps & Tips

1. Prepare your sketch. Next, lay down a drop cloth or newspaper to keep your floors clean. Use painter's tape to tape up your baseboards and the edges where the paint is essentially going to begin and end, along the corners where the wall begins and ends.

2. Using your painter's tape, create the shapes of the mountains across the room. Where your tape intersects, use your Stabilo All to mark off where to cut to create perfect points where the mountains overlap. Cut off the excess with scissors. Make sure the painter's tape is pressed down firmly and that there are no air bubbles or spaces where the paint could possibly seep in.

3. Paint two to three coats of chalkboard paint on the wall to create an even coat for the mountains, using your paint roller, foam brush, and paint tray. If you see streaks, you need another coat! Follow the instructions of your particular brand of chalkboard paint, but I would say to let each layer dry for a day to be super sure it's ready to be painted on again.

4. Once the chalkboard paint has dried, start mapping your space for lettering with the masking tape. Masking tape allows me to create curves with my lines as well.

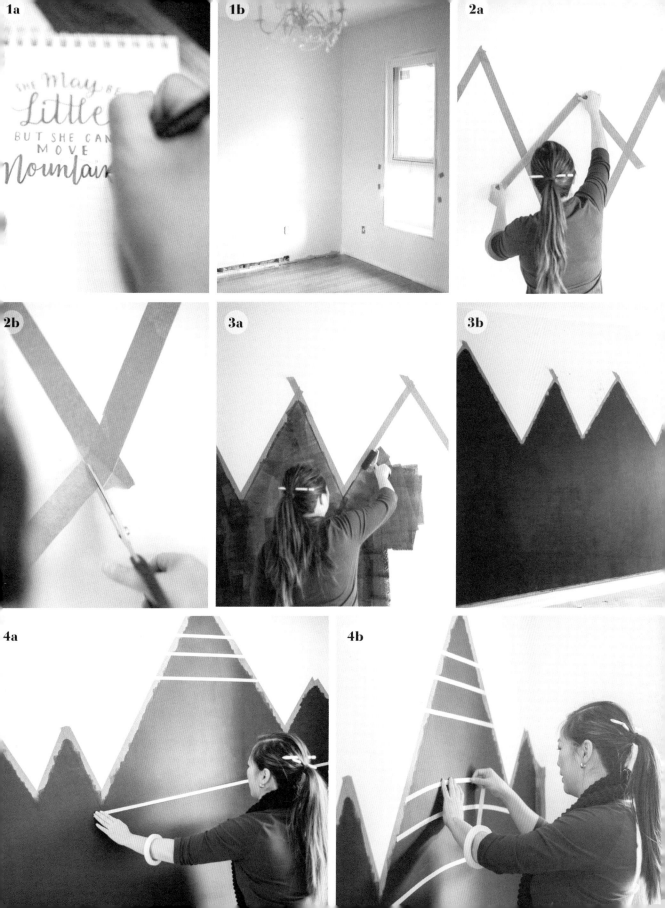

5. With your prepared pencil sketch in hand, sketch your quote with the Stabilo All. Since this pencil is water soluble, you can easily rub it off with a damp paper towel or cloth if you make any errors. I love this pencil for working on real chalkboard—there is no mess, it stays put, and I can sharpen it to create perfect points.

6. For the actual lettering, use the Sharpie oil-based paint marker, which is water-resistant, since we would like it to be permanent. The artwork will stay put even if you deep clean the entire board.

7. Remove your remaining sketch marks with a damp paper towel once the oil paint has dried. Ten minutes of dry time should be enough.

8. Remove the tape. This is my favorite part of every project! You now have a decorative chalk background with a quote within its mountainous terrain!

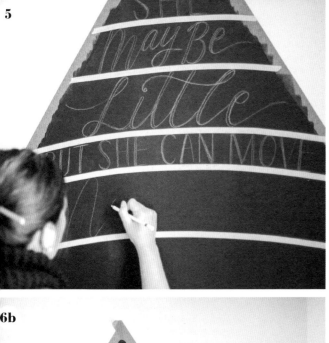

5

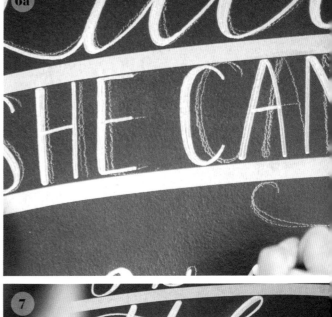

6a

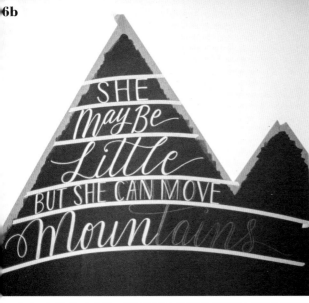

6b

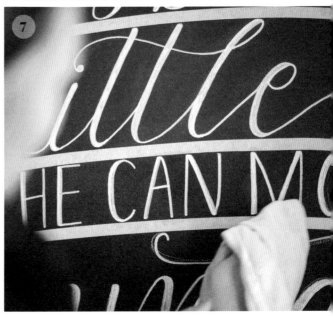

7

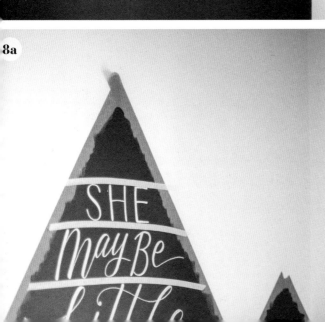

8a

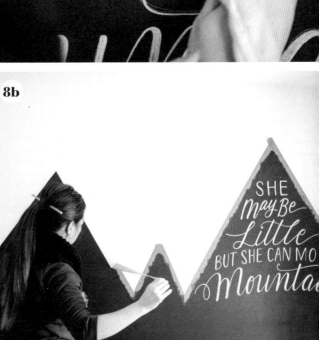

8b

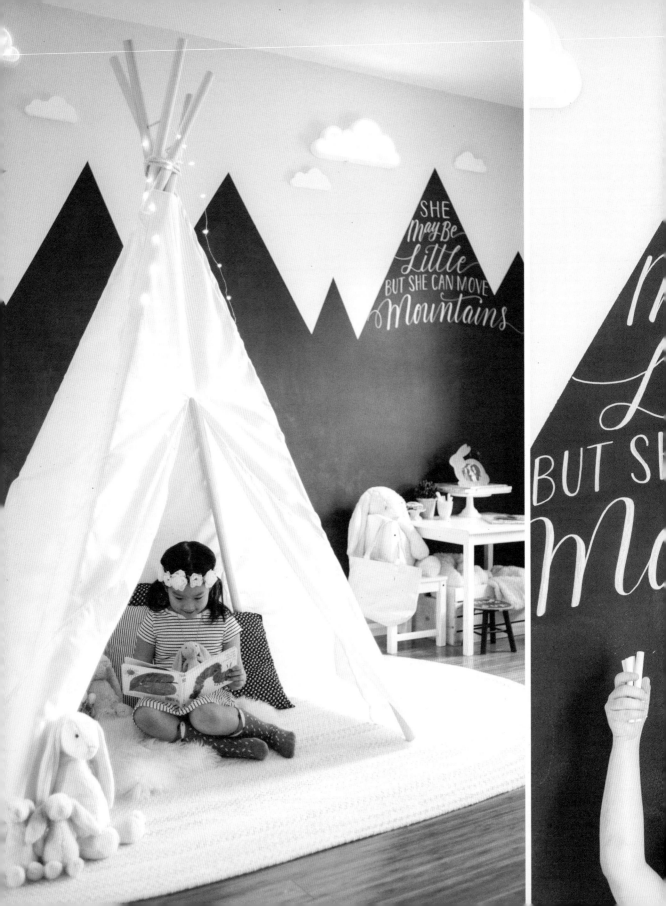

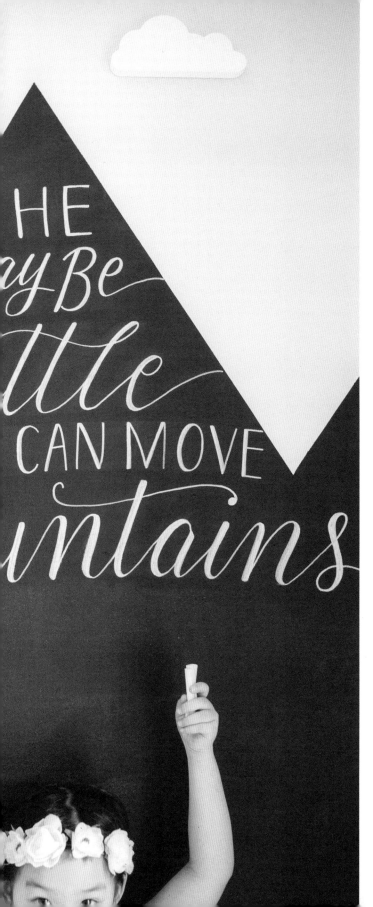

Consider all the other potential designs you can put on a wall. It could be a cityscape silhouette or a full wall galaxy with planets and stars, alongside a quote about adventure and exploration. The possibilities are limitless.

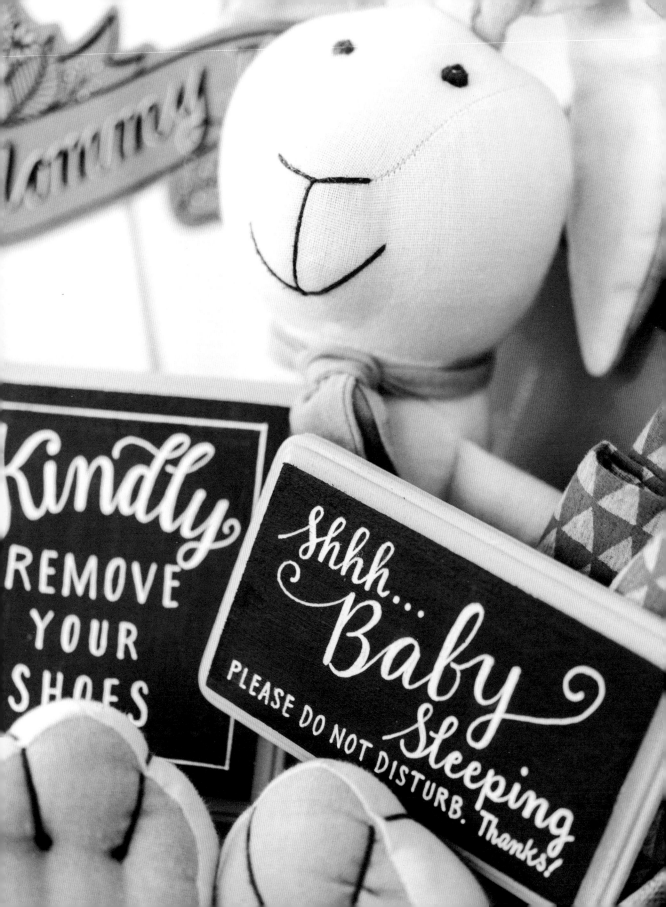

NEW BABY NURSERY CHALKBOARD SIGNAGE

I started creating mini chalkboard signage pieces out of necessity. After my daughter was born, unexpected knocks at the door would throw my miniature schnauzer into a frenzy, and nap time would be over before it began. After multiple occasions of this happening, I figured I needed a note, but I refused to use a simple Post-it. I started making "Baby Sleeping" signs to warn people not to knock or ring the doorbell and to text instead. Pretty and polite signage that solves real problems!

More signage came in handy when my daughter's crawling stages crept up on us—a simple "Remove Your Shoes" sign allowed us to keep the floors relatively clean for the little one's new adventure. I'm sure there are many more reasons out there for pretty and polite signs to exist! Let me show you how to create your own.

Tools & Materials

Small wooden plaque
Chalk paint
Paintbrushes
Acrylic paint
Masking tape
Bohin France mechanical pencil
Eraser
Molotow acrylic paint marker in EF
 (extra fine), white
3M command hook system (Velcro)

Steps & Tips

1. Always start off with a sketch to the size or specs of your sign. Choose the appropriate lettering for the occasion. This gift is for a little girl, so pretty and whimsical it is!

2. Head to your local craft store to source for wooden plaques, which come in many different styles and sizes. Choose one that fits your situation. I like signs that are hung outside the door to be small—not too overbearing but fully legible up close. I love plaques with beveled and decorative edges, which give it the perfect personality for a baby shower gift for a little princess. However, if you are making a bold sign like "Keep Out" or "Beware of Dog," use straight, serious edges!

3. Use chalk paint to paint the surface of the wooden sign, keeping the edges clean. You can use tape to ensure clean edges, but you can also paint freehand with a foam brush if you are confident. Foam brushes have flat edges that are great for keeping straight lines. After the chalk paint dries, paint the colored edge with an acrylic paint that suits the occasion, décor, or theme. Since acrylic is more durable, it will allow signs that are placed outdoors to better resist the elements.

4. Once your sign is ready to be lettered, map out your border with tape and sketch directly onto the surface with your Bohin France chalk pencil. Any errors can be quickly corrected with an eraser.

5. Next, use the Molotow paint marker to letter permanently. Make sure you shake your pen and test out your tip on a piece of paper first. *Never* test your pens on your artwork unless you want to gamble—if your pen happens to leak, you may have to start all over again. (The exception is testing your pens on the back of wood projects as every wood surface is different.)

6. Once the paint dries, give it 5–10 minutes, then erase your sketch marks from the Bohin chalk pencil. Remove the masking tape, and you are done!

7. EXTRA STEP! The easiest way to hang these signs is with a 3M command hook system (Velcro). The last thing a mom wants to do is go searching for a screwdriver and tools to affix a new sign. The 3M command hook doesn't ruin walls by leaving holes or ripping off paint.

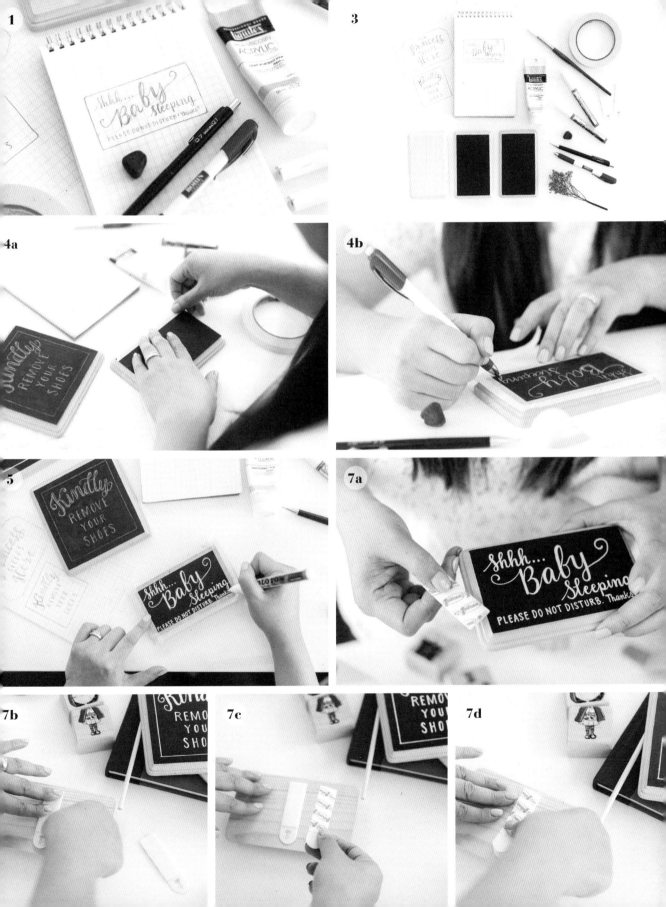

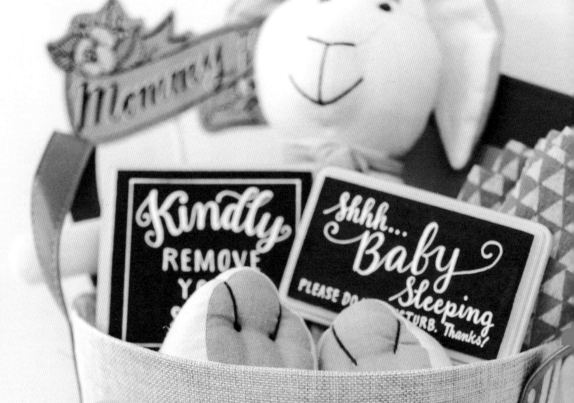

These small signs have been some of the most useful and unexpected baby shower gifts I have ever given since they cannot be found on a registry. They are always thoughtful and pretty, and especially handy to new parents with pets.

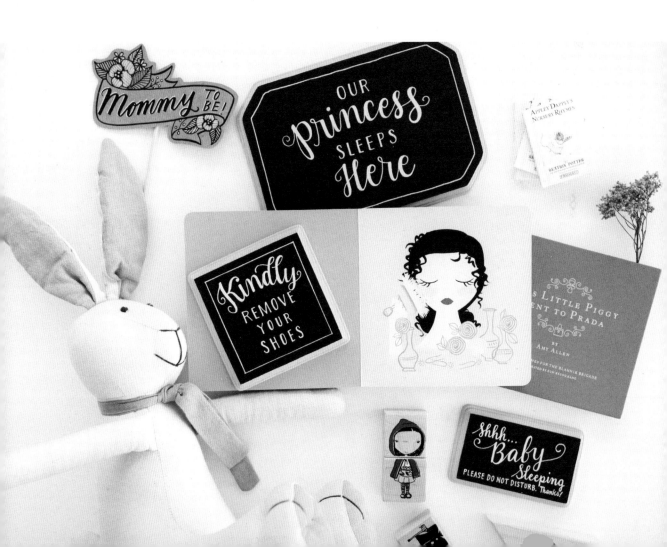

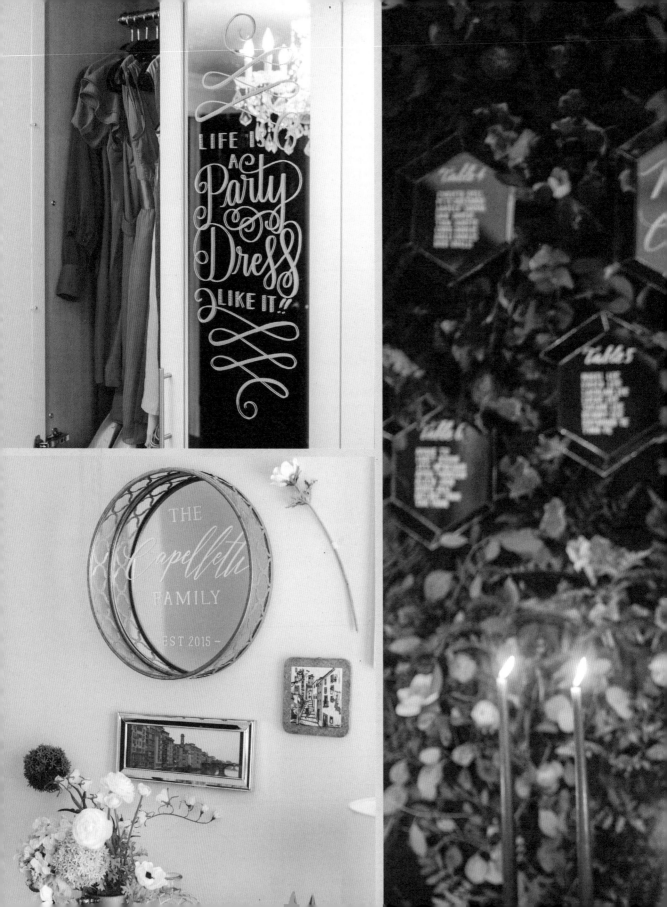

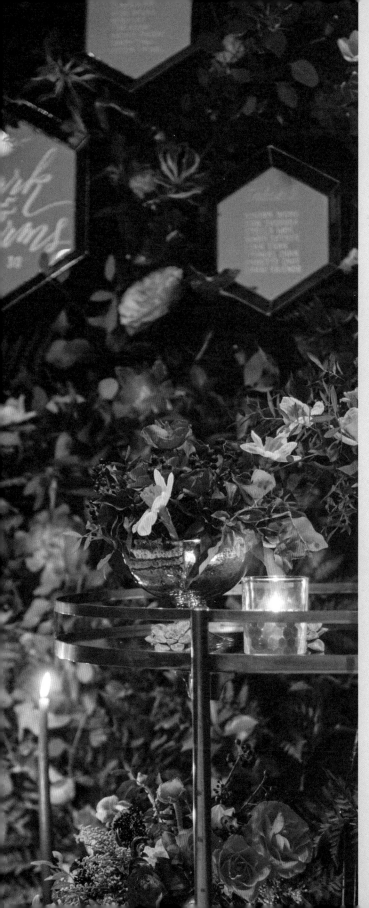

CHAPTER 9

Lettering

ON MIRROR

In the three mirror projects ahead, we will be creating a seating chart installation on a floral wall, a personalized family name piece for a housewarming gift, and a lettered mirror enclosed in an amazing custom closet.

I have been lucky to have the opportunity to work on hundreds of mirrors, and I find each piece absolutely beautiful. I especially love vintage and antique pieces. My fascination with all things old is undying, and I often wonder if the people who used to live among such beautiful things ever thought they were ordinary? Or did they find them just as wonderful as we do today? Even the calligraphy from our past was such an art, and to be able to bring them together is an absolute joy.

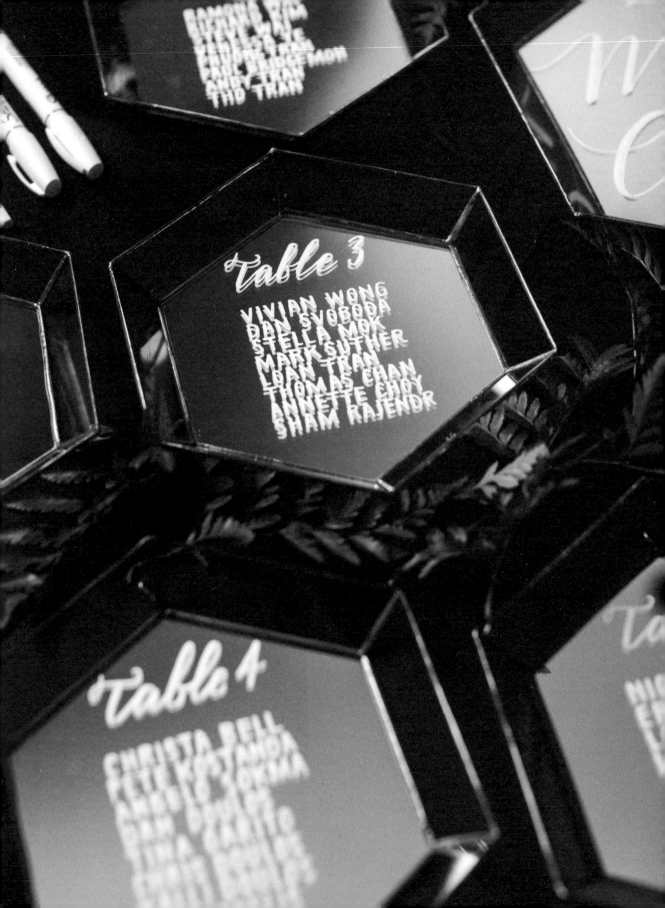

Event

SEATING CHART INSTALLATION ON FLORAL WALL

Weddings are one of the happiest and most celebrated moments in a person's life. I always feel a sense of responsibility and joy whenever I am commissioned to letter to mark this highlight in a couple's life. Signage for weddings is always important—besides food and drink, which are two of the most important elements for weddings, décor is next on that list! The best weddings show the personalities of the bride and groom in their favorite desserts, fun activities, and signature drinks, and signage is a design element that will bring all these together to form a cohesive look. My most requested wedding items are "Welcome" pieces and seating charts. My personal goal is always to make these functional pieces look so stunning that they can be considered art.

For this project, we are creating a seating chart using mirrors. Instead of using just one large mirror, I have decided to create a seating chart installation where each table has their own mirror, with the happy couple in the center of it all. Imagine your guests finding their seats through this beautiful and unique setup!

Tools & Materials

Mirrors
Stabilo All pencil, white
Sharpie water-based paint marker
Masking tape
Microfiber cloth

Steps & Tips

1. These hexagonal mirror and glass beauties were handmade specifically for this project by an amazing local glass and mirror artist (see page 148 for her information). Make sure your surface is always clean and oil- and dust-free. It's quite difficult to polish a mirror once the lettering is already applied. Sketching is minimal for this project—I only sketch out the bride and groom's names that will go onto the center focal piece, as well as each table number heading (for example, Table Four, Table Five, etc.) to ensure that they look similar. I don't sketch out individual guests' names as I usually use capitals and sans serif, and am comfortable lettering freehand.

2. Map out your space for the center focal piece with the bride and groom's names. I use masking tape with a low-grade adhesive for this project, as stronger masking tapes leave sticky residue behind. Sketch your design and composition onto the mirror with Stabilo All white pencil.

3. Use the Sharpie water-based paint marker to execute over the sketch. Remember: if you are creating calligraphy or script-style lettering, you must try to fill in the thicker strokes as you go—if the lettering dries and you apply the thicker strokes afterward, you may run the risk of scratching your first strokes, and that's when clumping happens!

4. For the rest of the pieces, map out the height and width space for the table number header with masking tape. I like to give each table number heading about 2 inches in height. Sketch out the table number header with Stabilo All, and execute with the Sharpie water-based paint marker.

5. I usually letter guest names freehand directly onto the surface without sketching. Legibility is very important when it comes to seating charts, so I letter their names in capital letters and simple sans serif lettering. I like to give each guest name about ½ inch in height. So, if each table has ten guests, which is a typical number for wedding tables, you will need a 7-inch-long mirror surface to accommodate the lettering, including the 2 inches at the top for the table number heading. I like to align the names to the left or keep them centered, though the former creates a more structured look I enjoy.

6. Remove the tape, clean up any sketch marks from the mirrors, and your mirrors are ready to be hung!

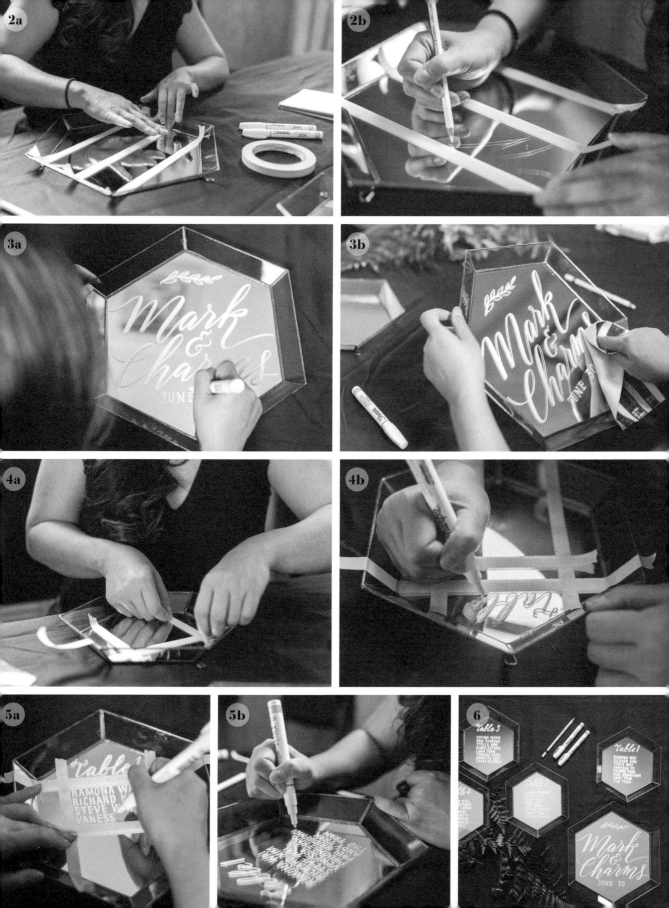

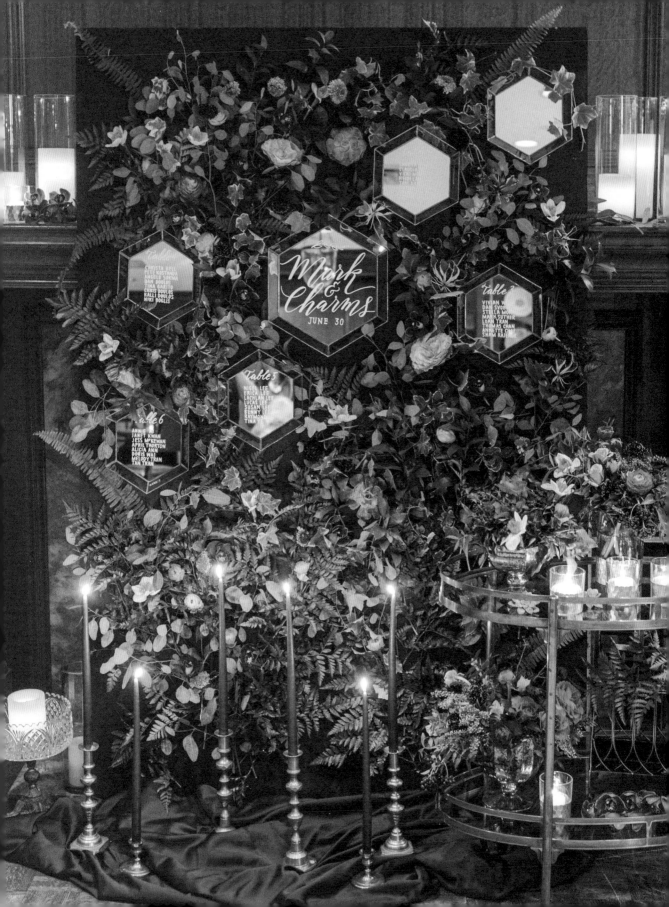

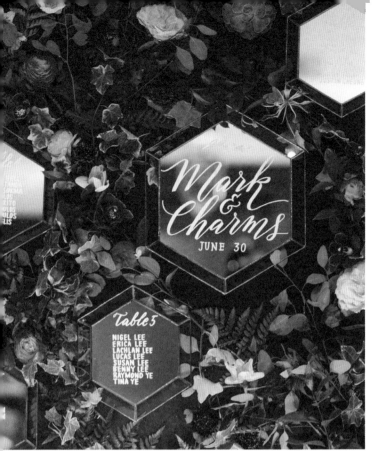

For this seating chart, these beautiful mirrors were mounted on a piece of plywood that was painted black. Flowers were then stapled all over the wood onto the board to create a stunning installation. The beauty of this setup is you can keep the mirrors after the wedding and use them for your own home décor on the wall. They can also be used as candle plates! The potential to upcycle these mirrors and reuse them again and again is endless.

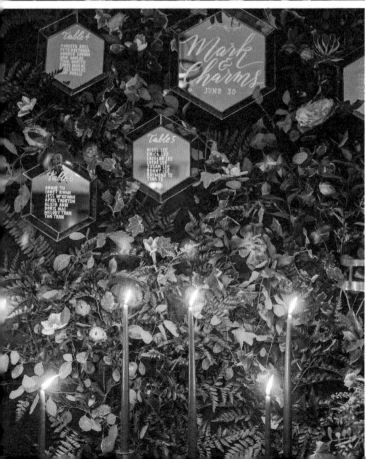

Seating Chart Composition & Design

If you own your own lettering business, you will find that seating charts are a frequent request. Here is how I lay out my charts for visual balance:

In most cases, clients always need a header—perhaps it's their names, or "Please be Seated," or "Your Table Awaits." So, you must allocate space for this every time. It's also important to know if they are organizing their guests by table number or alphabetical order, and whether the item provided to you is going to be a vertical or horizontal piece. The easier format is planning by table number.

Here is an example of twenty tables on a rectangle mirror on the left and nineteen tables (an odd number) on the right.

If your seating chart has to be alphabetical order, you will have to exercise your math skills! I swear I don't like whipping out the calculator, *but* for the sake of balance and good design it must be done! You will need about ½ inch in height for each name, 2 inches in height for the table number header, and nothing less than 6–7 inches for the width of each column.

For example, the picture on the right shows a mirror that was 47 inches wide and 31 inches tall, with two hundred guests.

I measured a border around the mirror before I started dividing the space up. I made space for a header as well. It is so important to plan and map out the composition beforehand, as an organized design layout will make your piece that much more beautiful.

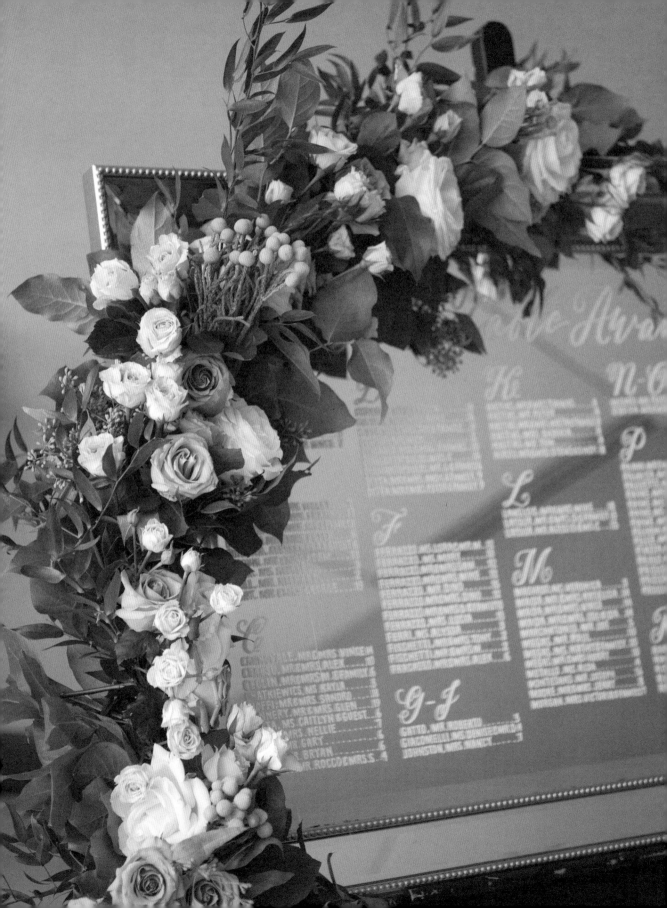

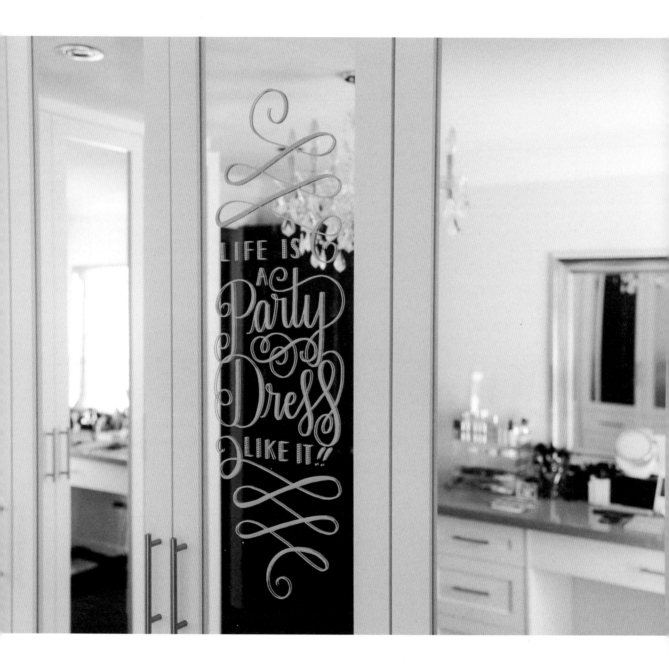

Home Décor

FABULOUS CLOSET QUOTE & INSPIRATION

Within five minutes of opening my eyes and getting up in the morning, I am standing in front of a mirror, facing my morning self. This is the first of many times I will meet my reflection throughout the day. I also have a vanity and a full-length mirror for dressing in the same room. The potential of what I can letter on these is always on my mind—it's like deciding on getting a tattoo, but in this case it's not actually permanent! For vanities, I love the idea of beauty or makeup quotes like: "Wake Up + Make UP!" or "Hello, Beautiful" or "May Your Day Be As Flawless As Your Makeup." For closet doors and dressing mirrors, I think about

words that relate to fashion, shoes, and clothes. For this project, we will be lettering the quote "Life is a Party, Dress Like It!" on a fabulous custom closet mirror. This is the closet of every woman's dream, filled with amazing bags, an array of fun and flirty shoes, and a modern rainbow wardrobe.

Tools & Materials

Masking tape
Stabilo All pencil, white
Molotow acrylic paint marker
 in Skin Pastel

Steps & Tips

1. Have your sketch ready and on hand, formatted to the size of your mirror. Make sure your mirror is clean and dust- and smudge-free.

2. Map out your border with masking tape, as well as your spacing, for composition. The tape is especially helpful when I letter basic fonts, as they keep my lettering height in line.

3. Sketch out your design on the mirror with the Stabilo All white pencil. All marks made can eventually be removed with tissue, so don't be afraid to create lines upon lines until the perfect sketch is complete. Sometimes you may wander slightly from your original sketch if you find that certain designs may be too busy or if you would like to add flourishes to make the piece more beautiful. It is your creation, after all!

4. Use the Molotow acrylic paint marker in Skin Pastel to execute the design. Molotow paint markers are a much more durable medium, and they stick to the surface much better than Sharpie water-based paint markers. The Molotow also comes in an array of colors. Since this is a fun project for a colorful closet, I figure the lettering can be a bit more colorful, too! This Skin Pastel is the closest to "blush" I could find. Color in the thick strokes as you go along, in order to avoid the clumps that will form if you go back to thicken an area when the paint has already dried. If you need to apply thicker lines on dried paint, apply with a feather-light hand.

5. Remove your tape to reveal your hand lettered creation! Now is the time to add any design elements/flourishes/illustrations. I always letter words first before I add any flourishes to my piece, since the lettering is the most important part.

6. Remove sketch marks with your tissue. This colorful closet, complete with a fun quote, makes getting dressed a party!

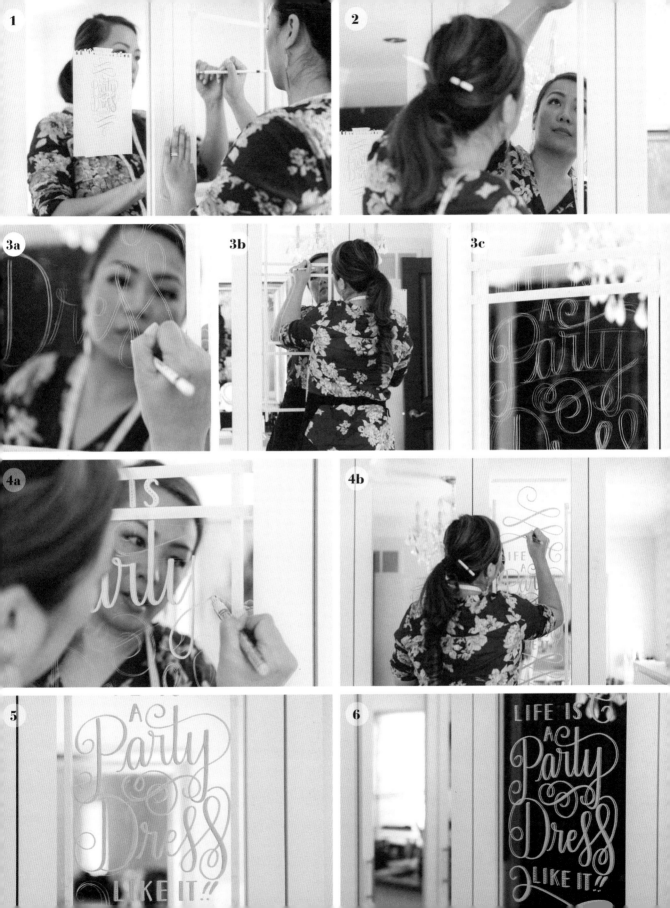

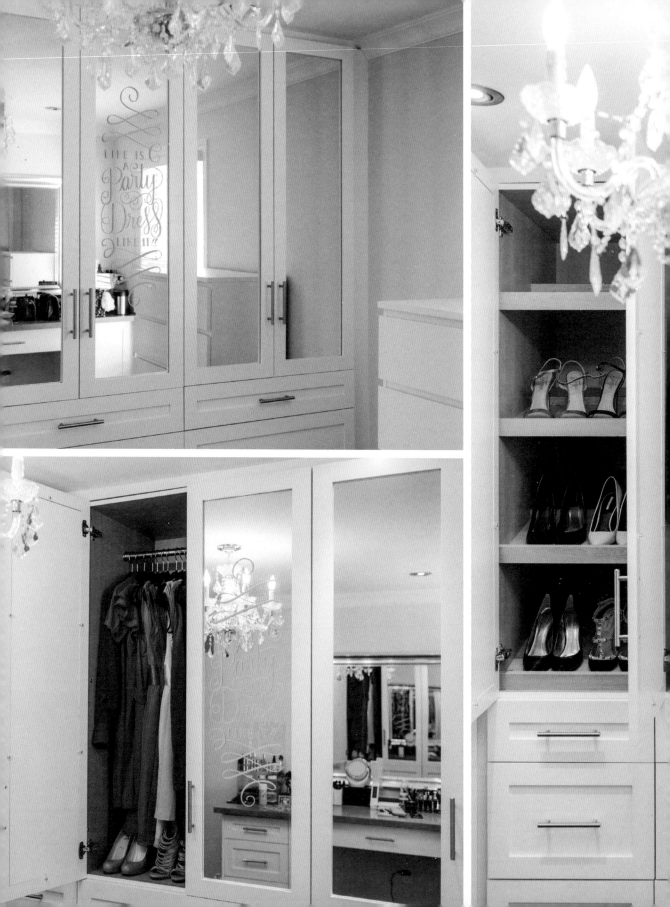

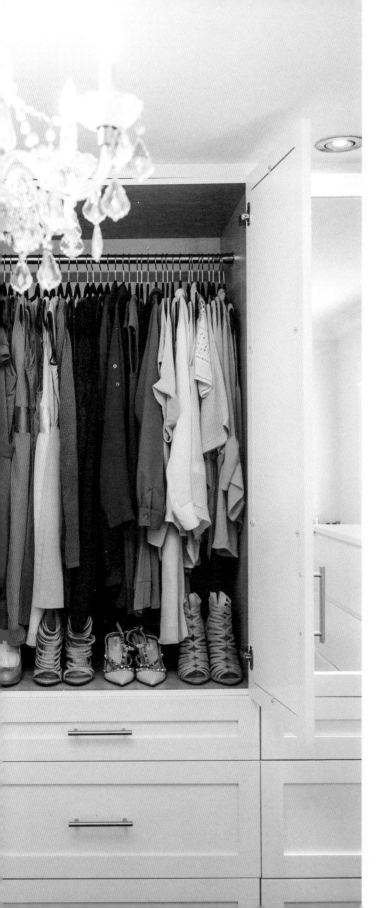

There are so many opportunities to infuse your personality into your home with lettering. Words that comfort you in a cozy room, words that inspire in a creative space, and lettered mirrors that add style and wisdom to any space!

Gift

FAMILY NAME MIRROR FOR THE HOME

Being able to letter on things makes gift giving really easy. Most people love personalized items, and you can always go beyond just a lettered name—think of a song lyric they love, favorite recipes you want to hand down to your loved ones, or inside jokes between friends. Lettering to personalize gifts is the definition of "it's the thought that counts" manifested in a very tangible item! For this project, I am creating a housewarming present for a new family home. This piece was actually a decorative tray meant to sit on a table, but I saw it as an opportunity to create a wall mirror, with a hand lettered family name and the year the family was established.

Tools & Materials

Mirror
Masking tape
Stabilo All pencil, white
Sharpie water-based paint marker, fine point, white
or
Molotow acrylic paint marker, white

Steps & Tips

1. Have the sketch of your family name ready. Make sure your surface is nice and clean.

2. Map out your sections with tape to ensure that all the lines are parallel to each other. Again, the tape acts like a guide.

3. Use your Stabilo All white pencil to sketch out your design on your mirror.

4. We will be using the Sharpie water-based paint marker for this project. This means the lettering can potentially wash off, but if it's meant to be hung and hands don't touch it, using this pen is perfectly OK. The Sharpie water-based paint marker in fine is my favorite out of all the white paint markers I have tried—I prefer the flow and the opacity of the paint is great. It's also super helpful that it comes in three sizes: medium, fine, and extra fine. However, if you want to go with durability, use the Molotow acrylic paint markers; however, the flow is not as free and sometimes it may be streaky. Just make sure the tip is well inked before laying down the tip to the surface.

5. Because I am right handed, I work from top to bottom, left to right, so my hands don't drag through any wet ink or paint while lettering. For smaller items, I turn things upside down to get a better angle of the surface. When items have high edges or frames, like this one, it can get a bit tricky to get near the edges of your surface.

6. Remove the tape and clean up any sketch lines. You'll have a beautiful piece to be cherished by the family for years to come.

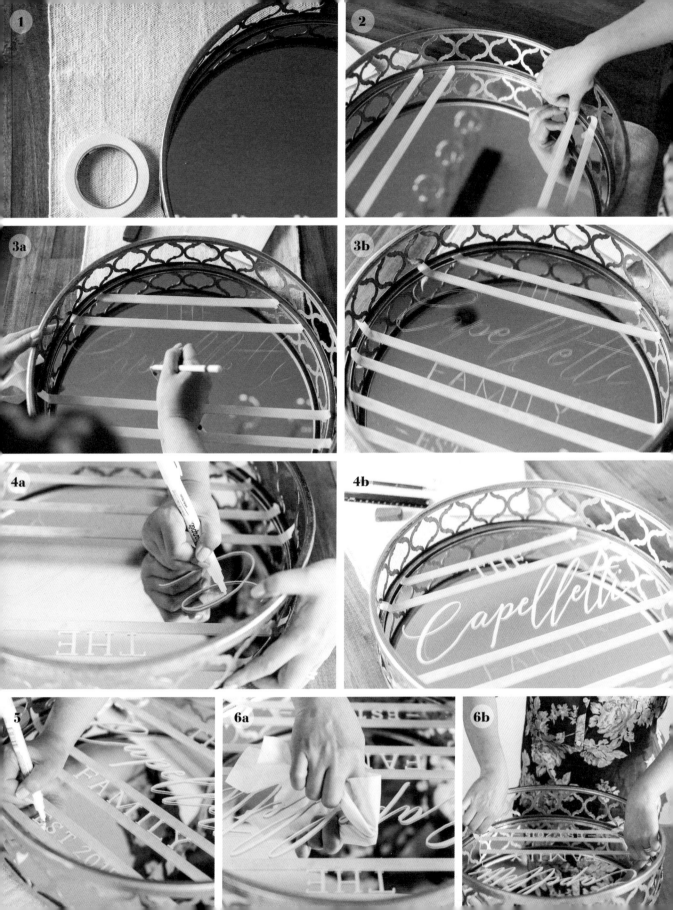

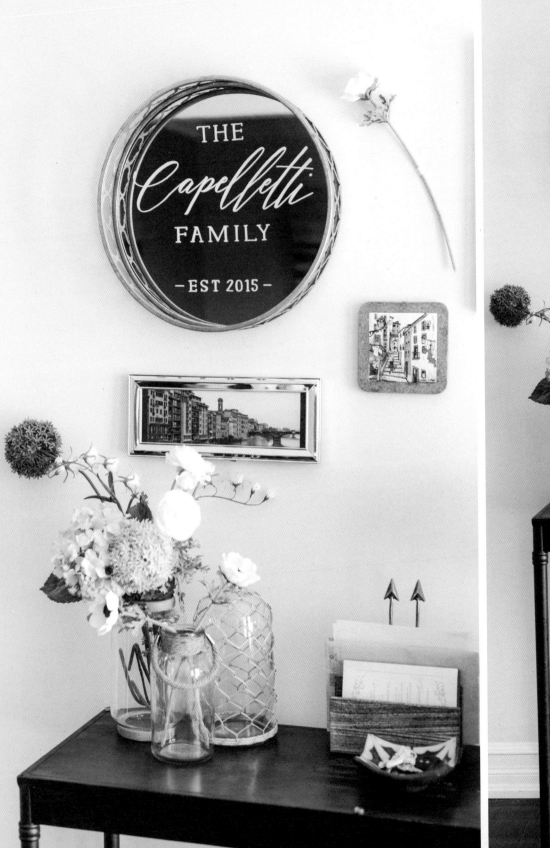

I love creating gallery walls of different items that express what our life is about. Mementos from our travels and meaningful photos of things we love and places we have visited.

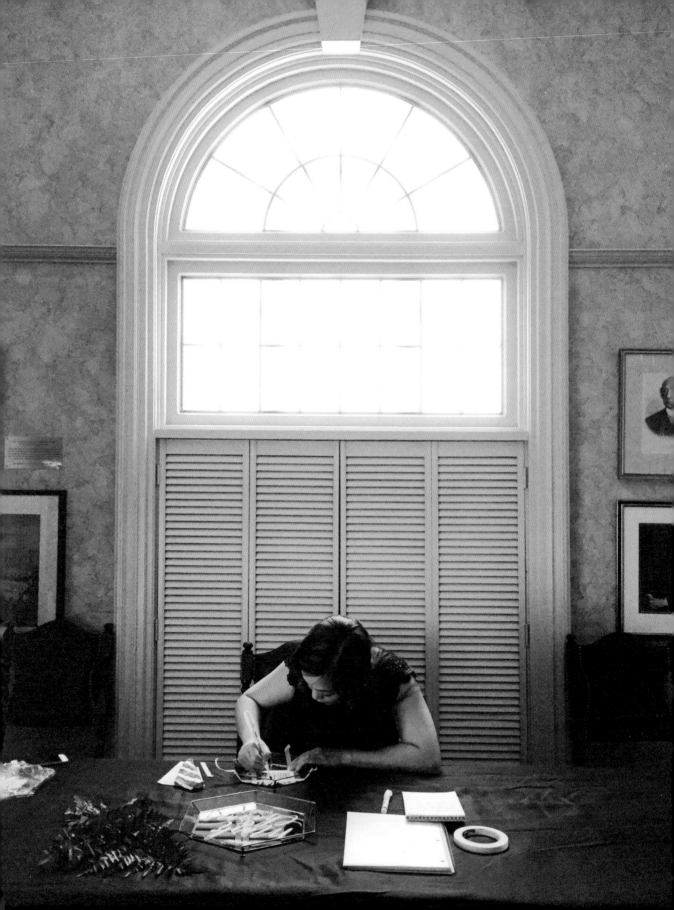

CHAPTER 10

FINAL THOUGHTS

As I wrap up this book about the inspirations, the ideas, and the many possibilities when it comes to lettering beyond paper, I reflect on destiny and what I am meant to do with my time and existence. That may seem like a really deep thought for something as simple as lettering, but let me say this: the simple art of lettering and my love for it has taken my life to really unexpected places; it has created the most joyous and authentic moments that show me who I really am and what I am about. To my very core, I knew that lettering was something I was born to do. It was just a quiet whisper in my heart, though the words never escaped my lips in my youth, until one day I could not keep it in anymore, and the whisper turned into a shout. It became so loud that it took over, and I have been lettering on autopilot ever since.

What if you collected a plate from each country you traveled to, lettered the name of each destination in a font that represented the country, and created an installation in the kitchen?

What if you lettered "Problem Solved, Temporarily" on a bottle of wine and sent it to a friend having a bad day?

What if you stripped and sanded an old table and lettered a permanent place setting for each member of your family?

You would be living the lettering lifestyle. This is my lifestyle.

Give me blank walls and I will decorate them, bring me empty frames and I will fill them, find me new tools and I will discover all their positive and negative abilities. It is my undying calling to continue to find new ways to use the art of lettering to inspire and create. The beautiful thing about this book and lifestyle is that reading the last page is not the end. I will never pretend to know the best techniques or tools; I just share what works for me now, and I encourage you to share with me and others your own lettering tools and ideas. I hope that we can inspire each other and continue to grow and nurture our passion of lettering and creating meaningful things.

I hope this book has flipped a switch in your mind and opened your eyes to what is possible when you letter beyond paper. Thank you for reading, for following my journey, and for lettering with me. This is your beginning of extraordinary hand lettering!

Share

Please share your projects with #extraordinaryhandlettering so I can follow your creative journeys.

GRATEFUL ACKNOWLEDGMENTS

In my life story thus far, there have been plot twists and turns that I could have never predicted—even this book was an unexpected chapter. And yet, at this point in my life, I could not have written the past chapters any better. If the world ended tomorrow, I would be at peace knowing I have lived my authentic life, doing and creating things I loved, and trying my best to share what I know. This book is one of the items on my bucket list that I've managed to cross off.

However, goals are never achieved alone, successes are sweeter when shared, and the hard moments are easier when there are amazing people to lean on.

To my mother and father, who have raised me and supported me throughout my years: thank you for seeing the spark of creative potential from those moments when I brought back my many paintings from kindergarten. I know that raising an artist was sometimes worrisome, but nonetheless you never tried to steer me off the path of creativity, and you encouraged me to study and pursue what was a clear passion from the beginning.

To my sister and brother, who have listened to me talk about my never-ending dreams and goals without judgment and brought me endless cups of bubble tea and Hong Kong–style milk tea: thank you. To grow up with both of you by my side is like having the sun and the moon, quiet and constant, predictable and dependable. Knowing in the darkest moments that there will always be a moon and knowing on the brightest days that the happiness you feel for me is genuine is a truly unmeasurable gift.

To my amazing team that brought this book to life: I really could not have achieved anything of this magnitude without some of the most creative, enthusiastic, talented, and hardworking people in the industry. They listened to me paint my picture of what *Extraordinary Hand Lettering* was about and what type of ripples I was trying to make in the lettering pond. Without hesitation, they jumped on board one by one, and we voyaged beyond the pond into uncharted waters of creating this book. It is really your blind faith in my passion that inspires me as an artist and person.

Annie, from the moment we met, you with a Chatime bubble tea offering in your hand, I was convinced that we were meant to be friends. I cannot really express into words how instrumental you have been to the whole process of this creative journey. Every moment and project we have worked on has been nothing short of amazing. It's not only the finished results that I love, it's also all the moments in between of planning, eating, planning to eat, and laughing that I cherish so very much. Your work ethic and dedication to the book has been nothing short of phenomenal, and I will always remember the moment you came through in a blizzard with those bar stools. Thank you for your talents and your support as a stylist, event planner, and fellow mom boss.

Janet, I believe I kept my word when I said we would work together somehow, but I could not have dreamed it would have been *this* wonderful opportunity. Thank you for your hard work and commitment to this book. The world through your lens is so vibrant, bright, and beautiful, and I cannot praise you enough for capturing what have essentially only been visions in my mind. You have this quiet ability to take photos that speak volumes, and it is a truly magical talent I admire.

Special thank you's to the following creative geniuses and entrepreneurs: Heidi, Lorrie, Joanie and Henry, Kathie, Caitlin, Katie, Toni, and Jess. I could spend hours penning my gratitude for each of you for your amazing talents and support. Your contributions and encouragement have meant the world to me, and in some cases overwhelmed to tears. It is because of people like you—as we meet over coffee, lunch, and FaceTime—that I believe anything is possible and goals are achievable.

The biggest thank you's of all . . .

To my dearest husband, Tan: thank you for your unending, undying, unwavering support throughout these creative years. I know that I am not the same woman you married ten years ago. I know you have watched me transform from a girl to a woman, fiancée to wife, and then into a mom. I know you expected that all of those roles would come to me, but to say that you knew you would marry a working artist, entrepreneur, and author would have been surprising; even I would not have believed it. You have so wonderfully stood by taking care of everything and our daughter as I went out to meet new people, build new relationships, and chase dreams. You never told me I was crazy, never doubted my abilities, and always cheered me on. All and any of my successes are a direct reflection of your dedication to our family and my work. You will always be one half of who I want to impress most in this world.

To my lovely daughter, Melody, the other half I strive to impress: to say you have given my life a purpose is the biggest understatement. The moment I became a mom—your mom—you gave me the greatest role of being your mentor. Every action I took from the day you arrived has been so calculated, and I view my life as if you were looking at me from the future. I hope that when you read this book, you can see who I am as an artist and a creative entrepreneur. You can find me throughout the pages of this book. This person was always in me before you came to be, and yet you were the catalyst and driving force that made me pursue it all. I want to spend all of my days showing you how wondrous life can be, how beautiful the world is, and how having passion, being authentic, and doing hard work will lead to endless possibilities.

And a final *HURRAH*! to all of you lovely readers—thank you for purchasing this book and making me believe that ideas are worth sharing. I am most looking forward to seeing *you* live the extraordinary hand lettering lifestyle.

VENDOR CREDITS

WOOD PROJECTS

EVENT: WHISKEY & CIGAR BAR
Photography: *Janet Kwan Photography*
Styling: *Madison & Ella*
Additional Props & Décor: *Southern Charm Vintage Rentals*
Food & Location: Nomé Izakaya

HOME DÉCOR: SECRETARY DESK CONVERSION TO COZY DINING SPOT
Photography: *Heidi Lau Photography*
Styling: *Madison & Ella*
Food & Location: *Sweet Esc.*

GIFT: HOSTESS GIFT BASKET
Photography: *Janet Kwan Photography*
Styling: *Madison & Ella*

GLASS PROJECTS

EVENT: PINK LEMONADE PARTY
Event Photography: *K. Thompson Photography*
Process Photography: *Janet Kwan Photography*
Styling and Rentals: *Southern Charm Vintage Rentals*
Desserts: *Cakelaine*

HOME DÉCOR: HOLIDAY WINDOW
Photography: *Janet Kwan Photography*
Styling: *Madison & Ella Events*
Additional Props & Décor: *Creative Bag*
Videography: *Henjo Films*

GIFT: AIR PLANT TERRARIUM WITH QUOTE
Photography: *Janet Kwan Photography*
Styling: *Love Lettering*

CHALKBOARD PROJECTS

EVENT: BLOOM SCHOOL BRIDAL SHOWER
Photography: *Janet Kwan Photography*
Styling: *Madison & Ella*
Florist & Location: *Hunt & Gather Florals*
Cake & Desserts: *Cakelaine*

HOME DÉCOR: CHALKBOARD MOUNTAIN WALL PLAYROOM WITH QUOTE
Photography: *Heidi Lau Photography*
Styling: *Confetti & Bows, Love Lettering*
Additional Props: *Pulp Function*

GIFT: NEW BABY NURSERY CHALKBOARD SIGNAGE
Photography: *Janet Kwan Photography*
Styling: *Love Lettering*

MIRROR PROJECTS

EVENT: SEATING CHART INSTALLATION ON FLORAL WALL
Photography: *Janet Kwan Photography*
Styling: *Madison & Ella*
Florist: *Periwinkle Flowers*
Hexagonal Mirrors: *Alicia Ann Glassworks*
Additional Props: *Southern Charm Vintage Rentals*
Location: *The Albany Club*

HOME DÉCOR: FABULOUS CLOSET QUOTE & INSPIRATION
Photography: *Janet Kwan Photography*
Styling: *Madison & Ella*

GIFT: FAMILY NAME MIRROR FOR THE HOME
Photography: *Janet Kwan Photography*
Styling: *Madison & Ella*

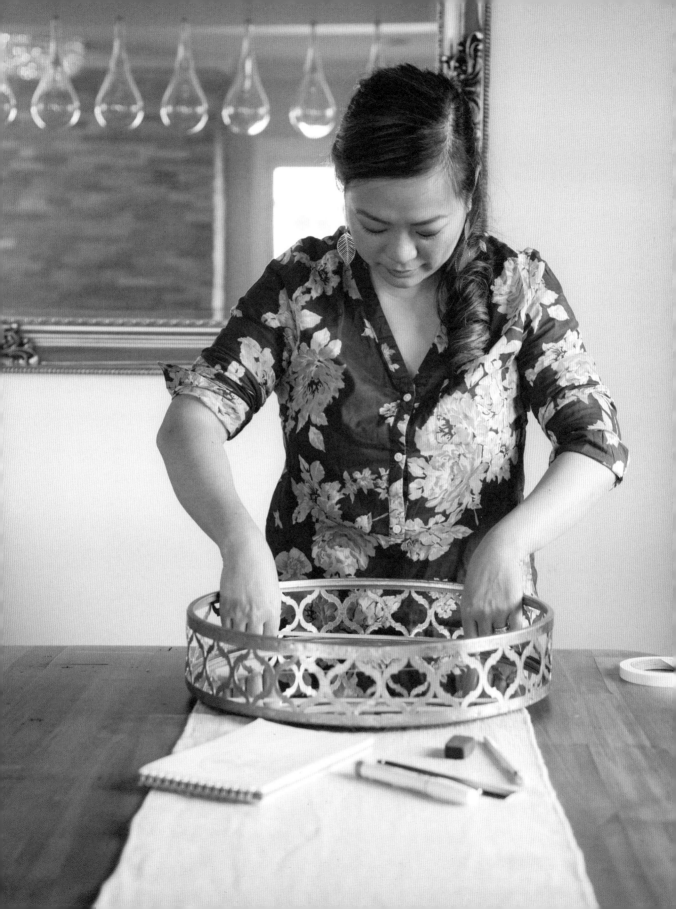